“My mother was an extraordinary woman who lived life to the fullest, with great passion, humor, and love. Though her loss is devastating to those of us who held her so close and so dear, we will always be inspired by her enduring contribution to our world. Her remarkable body of work in film, her ongoing success as a businesswoman, and her brave and relentless advocacy in the fight against HIV/AIDS, all make us all incredibly proud of what she accomplished. We know, quite simply, that the world is a better place for Mom having lived in it. Her legacy will never fade, her spirit will always be with us, and her love will live forever in our hearts.”

—Michael Wilding Jr.,
Elizabeth Taylor's oldest child,
March 23, 2011

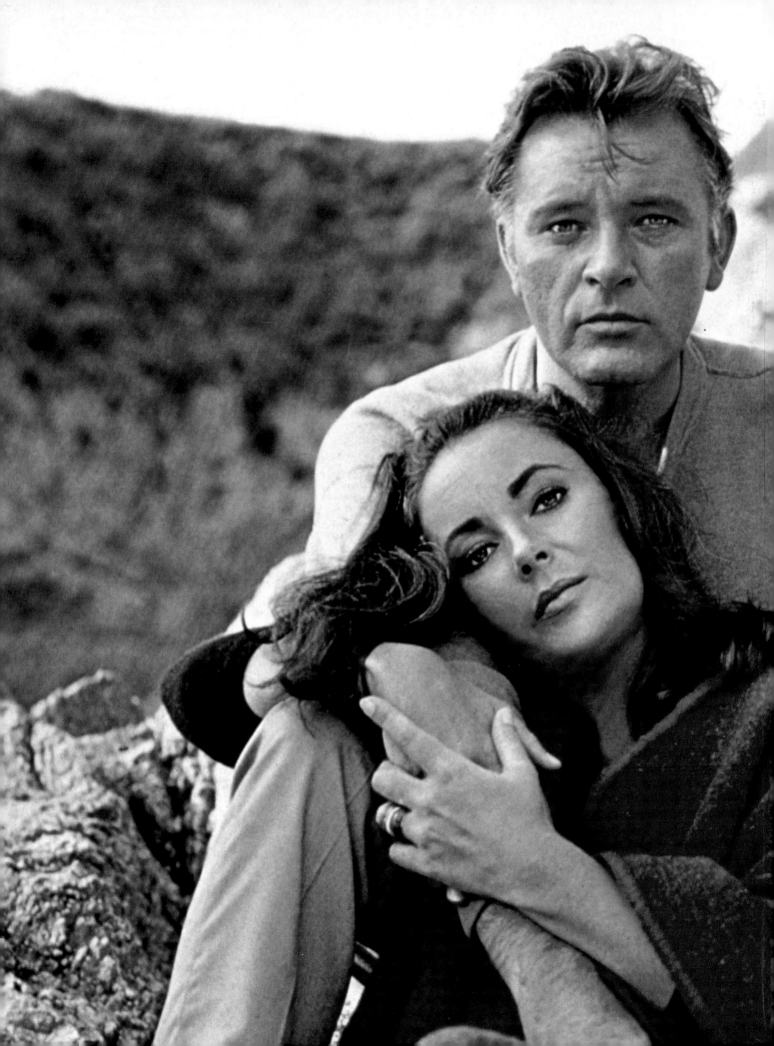

Remembering
Liz
1932–2011

Contents

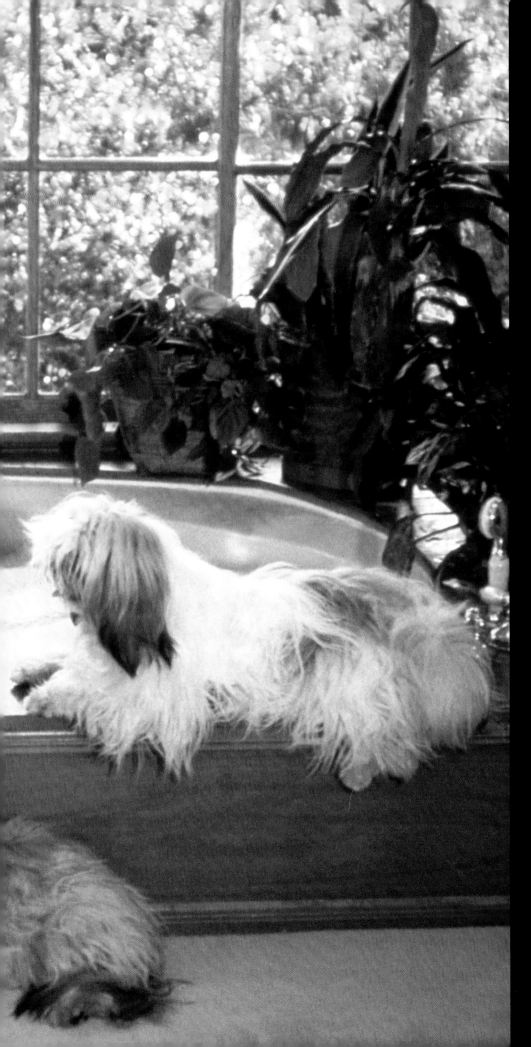

LIFE BOOKS
MANAGING EDITOR Robert Sullivan
DIRECTOR OF PHOTOGRAPHY Barbara Baker Burrows
CREATIVE DIRECTOR Mimi Park
DEPUTY PICTURE EDITOR Christina Lieberman
COPY EDITORS Parlan McGaw (Chief), Barbara Gogan
WRITER-REPORTER Marilyn Fu
CONSULTING PICTURE EDITORS Mimi Murphy (Rome),
Tala Skari (Paris)

PRESIDENT John Q. Griffin
BUSINESS MANAGER Roger Adler

TIME HOME ENTERTAINMENT
PUBLISHER Richard Fraiman
GENERAL MANAGER Steven Sandonato
EXECUTIVE DIRECTOR, MARKETING SERVICES
Carol Pittard
EXECUTIVE DIRECTOR, RETAIL & SPECIAL SALES
Tom Mifsud
EXECUTIVE DIRECTOR, NEW PRODUCT DEVELOPMENT
Peter Harper
DIRECTOR BOOKAZINE DEVELOPMENT & MARKETING
Laura Adam
PUBLISHING DIRECTOR Joy Butts
ASSISTANT GENERAL COUNSEL Helen Wan
BOOK PRODUCTION MANAGER Suzanne Janso
DESIGN & PREPRESS MANAGER Anne-Michelle Gallero
BRAND MANAGER Roshni Patel

EDITORIAL OPERATIONS Richard K. Prue (Director),
Brian Fellows (Manager), Keith Aurelio,
Charlotte Coco, Tracey Eure, Kevin Hart,
Mert Kerimoglu, Rosalie Khan, Patricia Koh,
Marco Lau, Brian Mai, Po Fung Ng, Rudi Papiri,
Robert Pizaro, Barry Pribula, Clara Renauro,
Katy Saunders, Hia Tan, Vaune Trachtman

SPECIAL THANKS TO Christine Austin, Jeremy Biloon,
Glenn Buonocore, Malati Chavali, Jim Childs,
Susan Chodakiewicz, Rose Cirrincione,
Jacqueline Fitzgerald, Carrie Frazier, Christine Font,
Lauren Hall, Malena Jones, Mona Li, Robert Marasco,
Kimberly Marshall, Amy Migliaccio, Nina Mistry,
Dave Rozzelle, Ilene Schreider, Adriana Tierno,
Alex Voznesenskiy, Jonathan White, Vanessa Wu

ISBN 10: 1-60320-223-4
ISBN 13: 978-1-60320-223-7
Library of Congress Control Number: 2011925969

Vol. 11, No. 8 • April 1, 2011

"LIFE" is a registered trademark of Time Inc.

We welcome your comments and suggestions about
LIFE Books. Please write to us at:
LIFE Books, Attention: Book Editors,
PO Box 11016, Des Moines, IA 50336-1016

If you would like to order any of our hardcover
Collector's Edition books, please call us at
1-800-327-6388 (Monday through Friday,
7:00 a.m.–8:00 p.m. or Saturday,
7:00 a.m.–6:00 p.m. Central Time).

COVER: BOB WILLOUGHBY

BACK COVER: EVERETT COLLECTION

PAGE 1: She lived in London her first seven years,
then swung into a new life in Los Angeles.
EVERETT COLLECTION

PAGES 2–3: The world's most famous couple,
known to all as Liz and Dick, in 1965, on the set of
The Sandpipers.

THESE PAGES: She was always rich in luxury and rich
in pets. During a 1982 LIFE shoot in L.A., Liz flashes
the 33.19-carat Taylor-Burton diamond, the first jewel
Richard bought for her back in 1968, as her Lhasa
Apsos, Reggie and Elsa, pay a visit.
NORMAN PARKINSON

Her LIFE

DID YOU KNOW SHE WAS NEVER PARTICULARLY FOND OF HER public nickname "Liz"? The most famous Liz in world history didn't love being called Liz. It's true. We at LIFE knew Elizabeth Taylor well since the days of her adolescence, so we were well aware of her preference for Elizabeth, and yet, as we see here, we were calling her Liz by the time she made her fourth cover, and were continuing to do so when she turned 60. She never held it against us—she willingly posed for all those covers, knowing many would be emblazoned with *Liz*—because she well understood, as we did, that to the public she was Liz, and the public owned a part of her. "Private?" she once asked rhetorically. "What makes you think my life is private?"

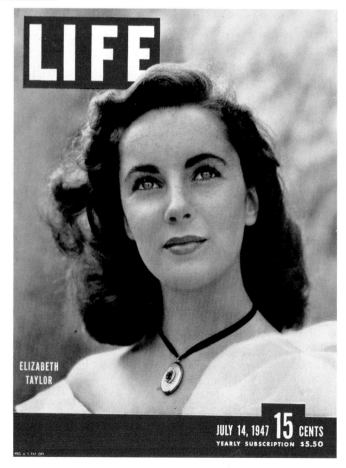

No one has ever understood the rules of celebrity better, or has been better equipped in terms of intelligence and aspiration to deal with them, than Elizabeth Taylor. Also: She was right for her time, and right for ours—and by ours we mean LIFE's.

The Golden Age of Hollywood, which gradually ceded to the Golden Age of Celebrity, coincided with the Golden Age of the Great American Magazine. It has been written (not least by us!) that LIFE was slow to understand the rock 'n' roll bombshells as they burst—Elvis, the Beatles. But we were as quick on the Liz Taylor story as we would be later on Jackie Kennedy's—in fact, we collaborated in moving those two stories along.

As we see at left, Liz first made the cover in 1947 at

age 15 in a Bob Landry portrait, though as we will learn shortly in these pages, LIFE's Peter Stackpole had visited the Taylor home in Los Angeles and documented the 13-year-old Elizabeth with her myriad pets back in 1945, right after *National Velvet* had been released. In the weekly and then the monthly LIFE, we stuck with the saga that was Elizabeth Taylor through the entire movie career and beyond. Stackpole visited, then Landry, then Halsman, then Mark Shaw and then Allan Grant and then Paul Schutzer and then Norman Parkinson. We stuck with the saga through the scandals, the triumphs and the travails—and Liz stuck with us. When Elizabeth underwent an operation to remove a benign brain tumor in 1997, she invited only LIFE and its photographer Harry Benson to visit her. Her history with Harry went way, way back; during his Fleet Street days he had hidden in a palm tree on a London movie set for 15 hours in an attempt to get the first pictures of her as Cleopatra.

She had come to know him, admiring two things she no doubt saw in herself—brass and charm. He made the lovely portrait of Liz at 60 for LIFE's cover, and now he would do the surgery story. We chose Benson's pre-operation picture for the cover, and ran the post-op, hairless shot inside. We knew that would become the famous photo, and this was so. But we wanted our Liz on the cover our way.

We stuck with her story, and now, with this commemorative edition, we close the book. We are saddened, of course, by Miss Taylor's passing—as are millions of her surviving fans, each of whom feels, today, as if they still own a part of her. Elizabeth always encouraged them to feel this way; she was unique in this.

In these pages we call her, alternatively, Elizabeth, Liz, Taylor, and, just here and with purposeful respect and Hollywood grandiosity, Miss Taylor.

We promise you: She would have been okay with this.

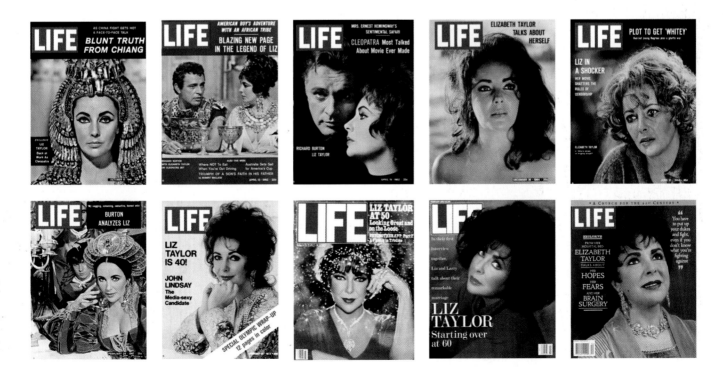

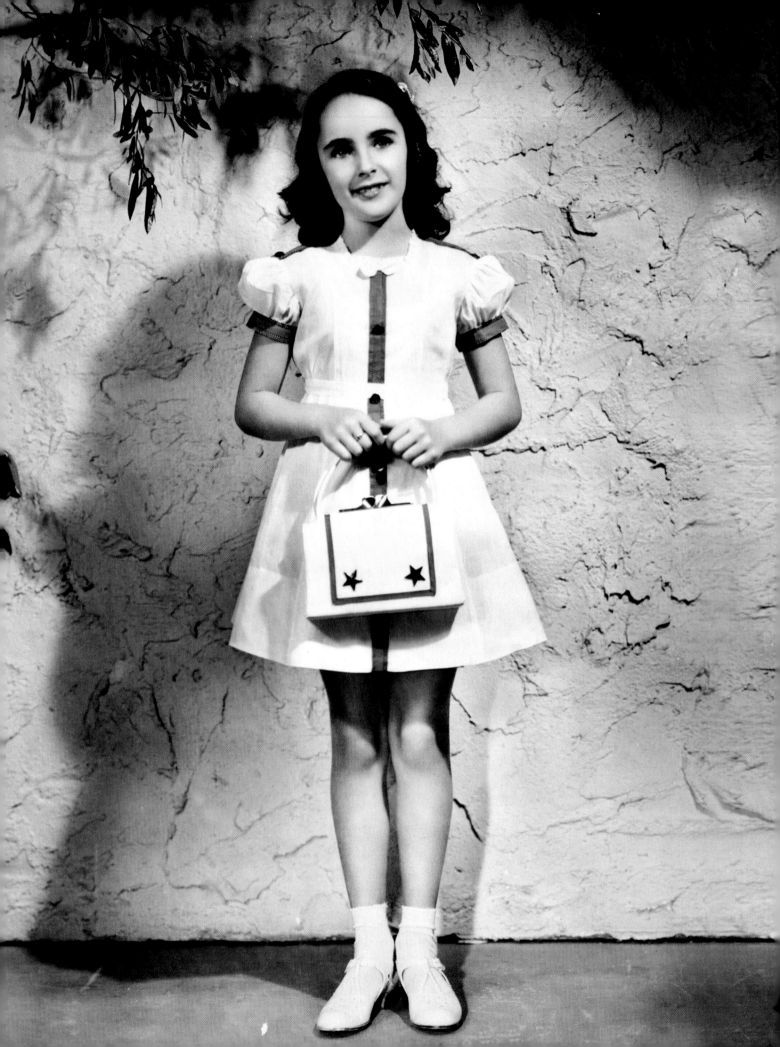

Child Star
1932–1947

THERE ARE STARS, THERE ARE SUPERSTARS, AND THEN THERE IS—WAS—Liz. Ne plus ultra. Even more than Marlon or Marilyn, she was the ne plus ultra. She lived so sufficiently long that, having met her as a child, we knew her (and knew her well, since she didn't shy from the public, always telling you what she was thinking) for a truly long time. And while she often lived in the extreme—never more so than during the fabulous, frantic, fraught years with Richard Burton, the "Liz and Dick" era—she never was ornery or too, too bizarre (save the eight marriages). She worked hard, played hard and performed good works. Who wouldn't want to live life that way? Who wouldn't want to end life having lived that way?

We loved Liz when she was a child. We reveled in her follies (but loved her still) when she was a diva-esque movie idol. And we applauded her (and loved her even more) when in her later years she gave herself over, as the Bible would urge, to the least fortunate among us. Whenever she visited Larry King, we tuned in to see how Liz was doing (often, recovering from this or that), what fabulous bauble she had bought lately and was perhaps wearing, and also: what she wanted *us* to do.

Liz was, without doubt, a piece of work. Adjacent to the phrase *a piece of work* in Webster's dictionary, there's a lovely picture of Liz; you can look it up. And she was an original. Looking back at the top-tier superstars of Hollywood's Golden Era, there is no other remotely like her, no other that comes close to her combination of talent, savvy, extraordinary beauty, evident empathy, charisma, sex appeal, recklessness, honesty, humor, hubris and a heartfelt sense of humanity. Did we say Liz was ne plus ultra? Seems we did. She was also sine qua non. She was essential; Hollywood needed an Elizabeth Taylor, someone who could put flesh on the bones of a celluloid celebrity. And we were lucky to have her for as long as we did.

Elizabeth Rosemond Taylor was always and forever an American—her parents were from Kansas—though various Tinseltown tellings see her as a kind of Bob Hope, a Britisher who made her way to the States, where she found her fate. Yes, she was born in London, in 1932, and spent her first seven years there. She was the second child of Francis Lenn Taylor and Sara Viola Warmbrodt of Arkansas City, Kansas, who were living abroad as Francis pursued his successful career as an art dealer. So she had dual citizenship from birth. When she became a wealthy movie star, she gave up her British citizenship so as not to be paying taxes twice, but got it back when she married Michael Wilding in England in 1952. She designated Great Britain as her official homeland after marrying the Welshman Richard Burton—"It is not true that I love America less, but I love my husband more"—and at the time of her death held two passports. But, yes, she was American.

Pretty as a picture throughout her adolescence, as soon as Elizabeth arrived in Los Angeles in 1939, folks were saying: "That girl should be in the pictures."

Her mother, it's interesting to note, was, at the time of Elizabeth's birth, a retired actress whose stage name had been Sara Sothern. Mom was in no way dissuasive when young Liz displayed tendencies for performance. Not yet five, the girl danced with students at the famous ballet school run by Betty Vacani in South Kensington, for an audience that included the Duchess of York and her daughters, the princesses Elizabeth and Margaret. (Miss Vacani would also tutor the two princesses and, among a multitude of others, the young Prince Charles and Lady Diana.)

Her father's London gallery was doing well, but in the later 1930s, London was not. The Taylors decided to return to the States in 1939 as storm clouds gathered. Not long ago, Elizabeth Taylor added interesting details about the family's move—details that, along with Liz's association with the Vacani School, confirm that the girl traveled in aristocratic circles from the first. In 2007, on the occasion of the movie star's 75th birthday, *Interview* magazine gave over a whole issue to a celebration of all things Liz. A lot of the features were pure fluff, but the centerpiece chat with editor Ingrid Sischy was, as all of Taylor's conversations were through the years, supremely entertaining and often fascinating. According to Liz, it was British prime minister Neville Chamberlain himself, when he was right in the middle of an appeasement of Hitler that would cost him his job and forever stain his legacy, who approached Elizabeth's dad and said, "Francis, you'd better take your family back to America." Taylor continued to Sischy: "So we were sent packing, and when I arrived in Hollywood, they called me the Little Refugee." For good reason, as London was soon being bombed by the Luftwaffe.

On the voyage from London to the States aboard the S.S. *Manhattan* in April 1939, Elizabeth watched a movie, *The Little Princess,* starring Shirley Temple.

The seven-year-old determined then and there that she wanted a career on the screen, though not necessarily as the next Shirley: "I don't want to be a movie star. I want to become an actress."

Her precocious aspirations would, of course, be fulfilled, but first she would indeed become a child star.

Whenever any beautiful thing—toddler, adolescent, soda jerk—alit in L.A. in this period, it was assumed that this beautiful thing aspired to a film career. It was also assumed that studio talent scouts were always trolling, as indeed they were. In a place where these were the operative rules, more than a few visitors to Francis Taylor's new Los Angeles gallery suggested that lovely young Liz had what it took. Such flattery delighted Elizabeth's mother, Sara.

Through a friend, the Taylors were introduced to the influential columnist Hedda Hopper, who wrote about a visit to the gallery in the newspapers and even mentioned the pretty young child. Nothing came of that, but another of Francis's patrons, a friend named Andrea Berens, twisted the arm of her fiancé, Cheever Cowden, chairman and principal stockholder at Universal Pictures, insisting that he had to meet this kid who looked like a young Vivien Leigh. After an audience over tea at the Taylors came an audition and a six-month contract at $200 per week. In 1942, Elizabeth Taylor bowed on screen in *There's One Born Every Minute,* which would be her first and last Universal picture. "She can't sing, she can't dance, she can't perform," said studio production chief Edward Muhl in arguing that Cowden should not renew Elizabeth's contract. "What's more, her mother has to be one of the most unbearable women I have ever had the displeasure to meet." And there was another problem: Barely 10 years old, Elizabeth, especially onscreen, looked older than her age, and casting her as this or

A year after Elizabeth found early fame with the 1944 film National Velvet, LIFE *magazine comes calling and asks the 13-year-old to pose with her horse, Peanuts.*

PETER STACKPOLE

10

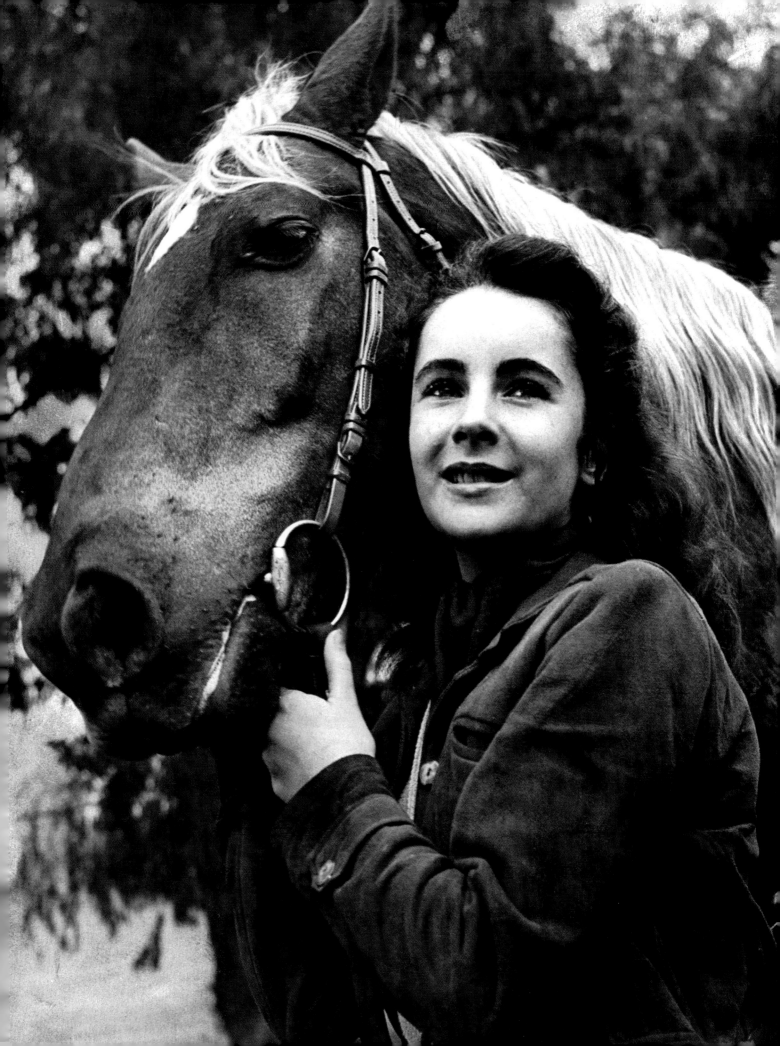

that child was problematical. She was sweet like Shirley Temple, but there was something *else*—something *way* else. If this was momentarily a curse, it would prove a long-term blessing.

Being dropped by Universal was another short-term problem that worked out just fine. In 1942, Metro-Goldwyn-Mayer offered her a screen test, overseen by producer Sam Marx, who had been an air raid warden in Beverly Hills along with Francis Taylor. Marx and MGM, the biggest, brightest and best studio at the time—"More Stars Than There Are in Heaven"—offered Elizabeth $100 a week for three months and a principal supporting role in a picture that would star a dog: *Lassie Come Home*. Also in the film was Roddy McDowall, already a child star, who would become a lifelong friend. (Taylor's allegiance to friends was legend, and the number of her friends was legion.) *Lassie* was a success, and Liz was on her way, signed to a seven-year deal on an escalating scale from $75 to $750 a week. She had small roles in two movies, *Jane Eyre* in 1943 and *The White Cliffs of Dover* (also with McDowall) in 1944, and then hit it big at the age of 12.

MGM was going to make a movie about a horse: *National Velvet*. Elizabeth had been riding since she was three and a half, and pleaded for the role. She was told she was too small, so she decided to get bigger, quickly. According to LIFE's reporting at the time: "By eating steaks and going riding and roller-skating every day she managed to grow three inches in four months and was given the part. In it she handled a spirited Thoroughbred horse, the film's hero, with an ease that astounded his trainers." After the movie was a smash in late 1944, Elizabeth Taylor was elevated to a rung already occupied by such other youngsters as Temple, McDowall and her *National Velvet* costar, Mickey Rooney.

During the filming of the movie, she had been thrown from a horse and badly injured. Back pains, perhaps attributable to this incident, would be chronic throughout her life, joined along the way by a host of other ailments, some of which were certainly lifestyle related. She grew famous for her surgeries—more than one hundred in all—and when she was on top in Hollywood, detractors unkindly alleged that she was showing off, and courting publicity, by checking into the hospital yet again. Later, of course, the health problems were serious indeed and evident to all, and Taylor's fans held their breath each time until she was released. She would then return to *Larry King Live* with the latest progress report. Until she could no more—and King's show was gone, anyway.

But all that was in the distant future in 1944 when *National Velvet* racked up grosses of $4 million at the box office. Two years later, *Courage of Lassie* (animals again! It's a wonder she didn't finish her career playing cameos in the *Beethoven* movies, or in *Secretariat*) was another hit, as was her 1947 loan-out to Warner Bros., *Life With Father*, which starred A-listers William Powell and Irene Dunne. She was in the major leagues now, and that year she made her first LIFE cover—a portrait of sweet, 15-year-old Elizabeth, wearing a simple locket, gracing the July 14 issue. It was a black-and-white photo, of course, and although most moviegoers realized the Taylor girl was lovely, they still hadn't felt the full force of those violet eyes.

She bid farewell to childish things—or, at least, to adolescent roles—in triumph, playing Amy in the now classic 1949 version of *Little Women*. She herself was no longer a little woman, hadn't been for a while. And she was poised to embark upon an adult career, public and private, that would leave fans asking at her death, as they wouldn't have to with Temple, McDowall or Rooney: Didn't she start out as a child star?

She's still 13—the same age as she was when posing with Peanuts—and is still considered pretty. But she is dangerously close to her eternal agnomen, "Beautiful."

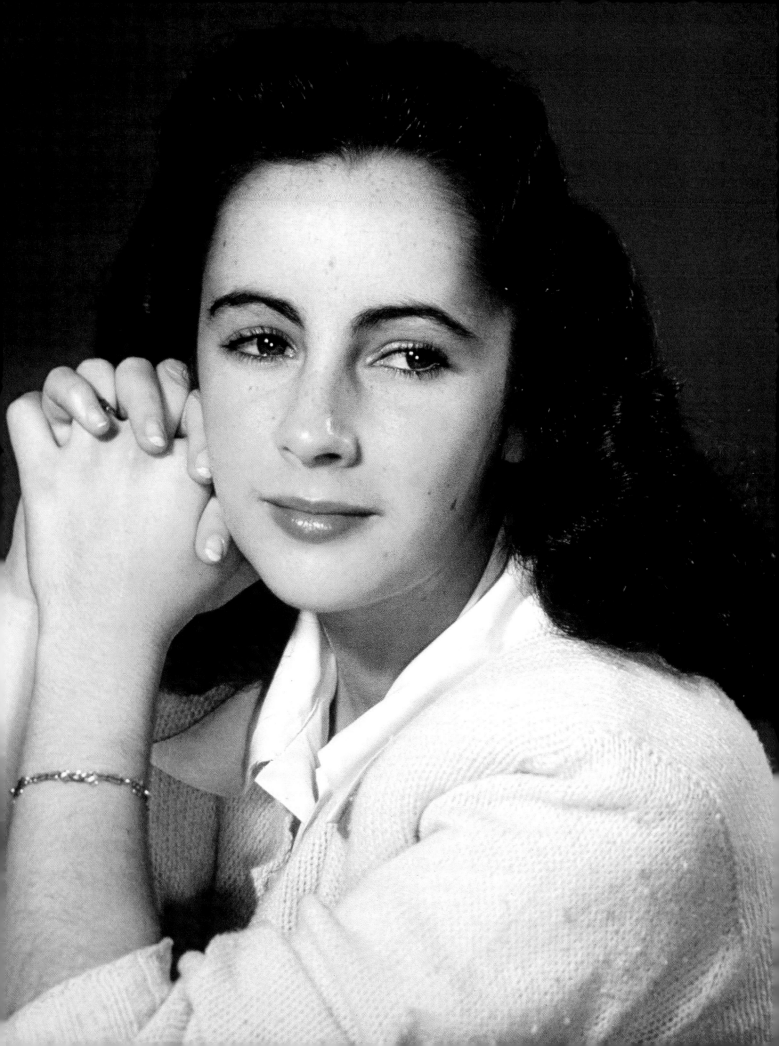

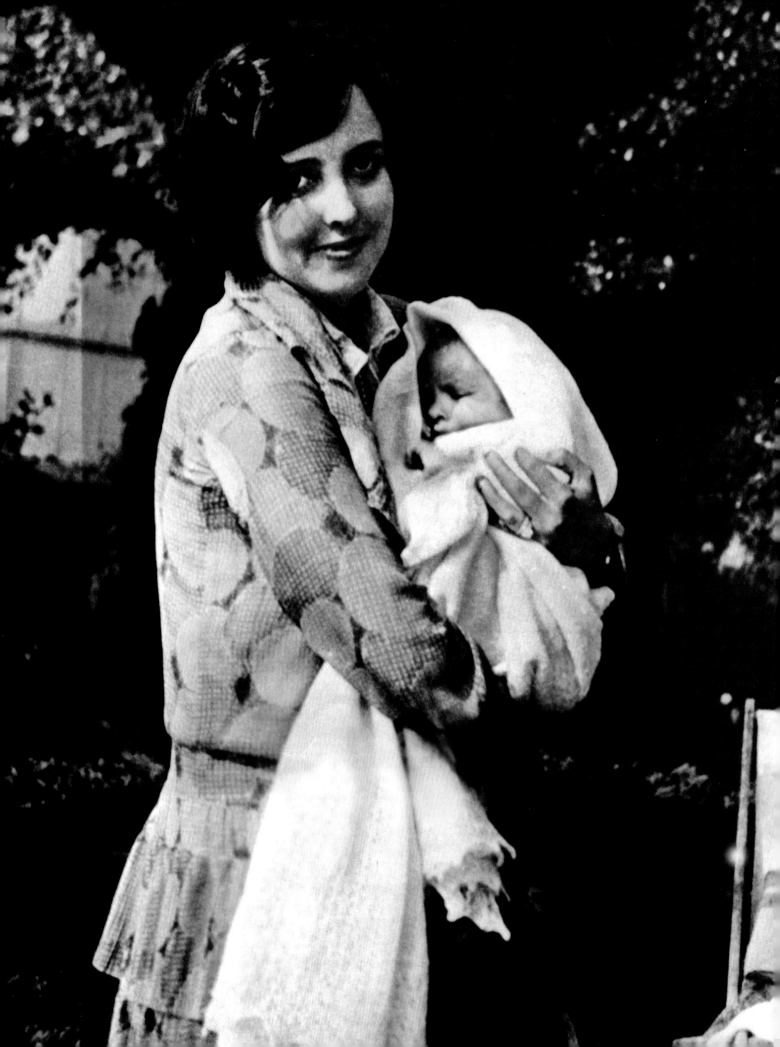

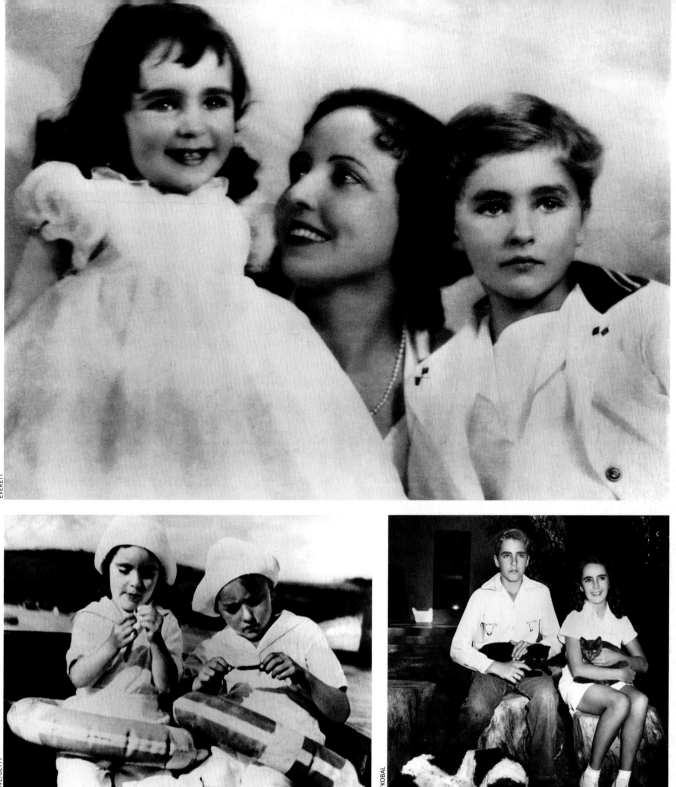

O pposite: In 1932, Sara Taylor cradles her infant daughter at home in London, where the family would remain until decade's end before returning to their native country, the United States. When Francis and Sara finally did relocate with their children to escape the Nazi threat, it was not, however, to their homeland in the heartland of Kansas, but to sun-splashed Los Angeles—La La Land—where Elizabeth, in particular, would meet her destiny. In California, Sara would develop a reputation among movie directors of the 1940s as a stage mother to be avoided at all costs, while Elizabeth would be in demand as a child star not to be

denied. But of course none of that could have been foreseen from the vantage of London in the 1930s. This page, counterclockwise from top: Elizabeth, two and a half, and her older brother, Howard, with their mother; a couple of years later with Howard, ready for a swim; and, finally—America, here we come, as Howard, Elizabeth, the family dog and two cats pose in Los Angeles (animals would be ubiquitous in Liz Taylor photography from here on; her menagerie will include species canine, feline, equine, avian and, as we will see on page 18, rodent). In this final photograph, she is on the cusp of becoming a teenager, and then a film star.

Still a girl, but with a big-time job. *This page, counterclockwise from left: Elizabeth plays with dolls at age 11, in 1943; a PR study of* Girl and Dog *(the suggested period caption for the studio handout read: "Lassie the $10 collie runt who became a high-priced star in the movie* Lassie Come Home *stamps an inky paw on a five-year contract with MGM, aided by 11-year-old Elizabeth Taylor . . ."); Elizabeth and Mickey Rooney in her breakthrough film,* National Velvet. *Opposite: The movie's two big stars. Mickey received fine notices too but was overshadowed. He was already a certified wunderkind, while this Taylor girl was news. In retrospect, Rooney can be viewed at this precise moment in his career as a cautionary tale. He had hit it big as early as the mid-1920s in the Mickey McGuire movies and then as Andy Hardy. He went even bigger in a series of films opposite Judy Garland. No one knew it in 1944, but* National Velvet *would prove his peak with the mass audience (unless you count his not-long-ago appearance in* Night at the Museum*). Rooney was drafted into the service after making the horse picture with Liz, and when he returned to Hollywood two years later after entertaining the troops, he was 26 years old, and postwar moviegoers were no longer avid for his brand of innocence. Whether Elizabeth noticed this or not, she would experience a seamless transition from child star to film star—perhaps the most seamless such transition ever in the annals of Hollywood. She never missed even half a beat.*

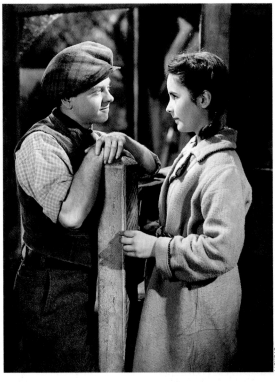

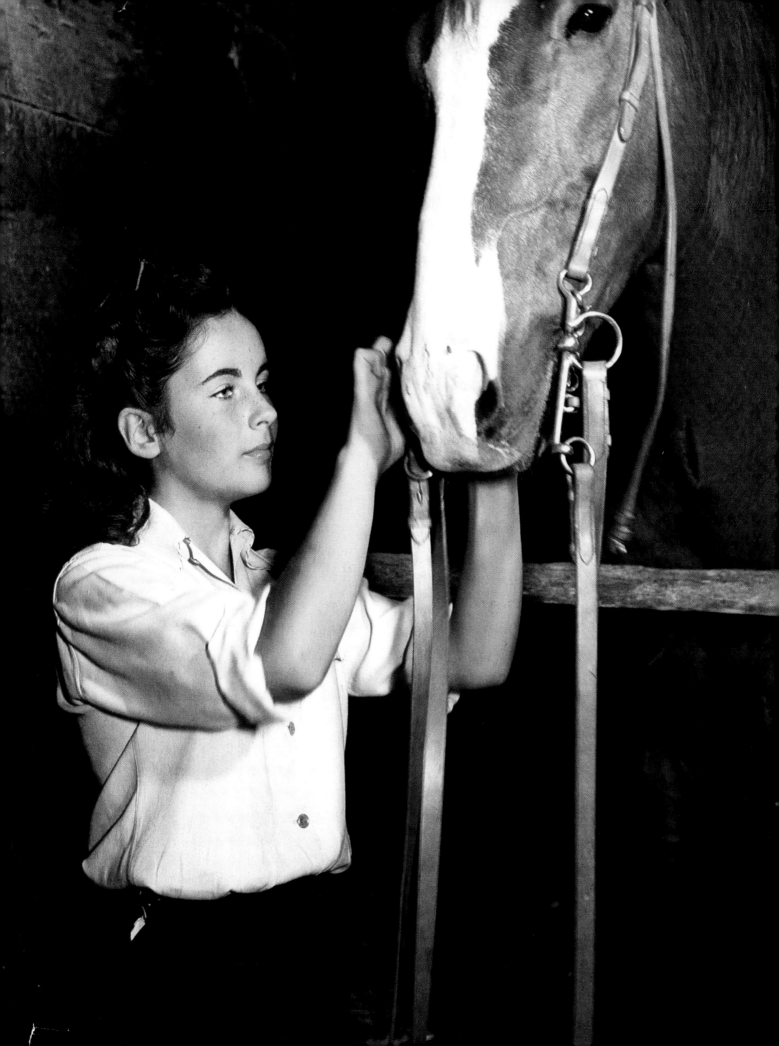

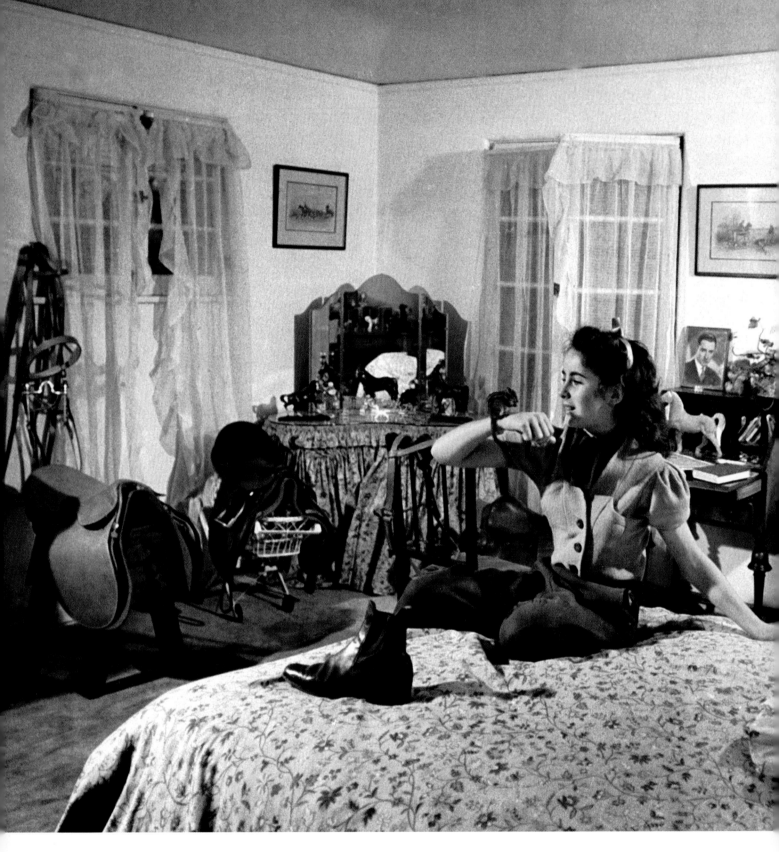

LIFE's *Peter Stackpole, who would shoot Elizabeth early and often during her child-star years—he practically owned the Young Liz beat at the magazine—pays a first visit in 1945 and of course finds animals scurrying about. Clockwise from above: Liz is in her bedroom in Beverly Hills with, according to* LIFE, *"favorite chipmunk Nibbles. She caught him in a trap made with an apple box and a long string"; and with a "black cat named Jill, [who] is one of a whole household of Elizabeth's pets. Others include three dogs, seven chipmunks, a bowl of fish. She often lets the chipmunks sleep in a cage in her room"; and with her three dogs, who are "a cocker, a golden retriever, a springer spaniel. Before she became an actress, Elizabeth seldom went to movies, preferred to play out-of-doors with her pets." The same would be true after she became the most successful actress in the world; animals were always prominent in her day-to-day life. As for the animals seen here: One was apparently special. Many years later, Liz recalled the long-*

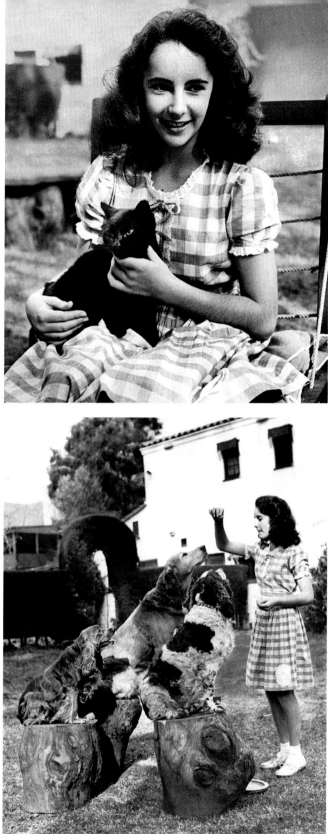

gone rodent Nibbles, movingly and sadly, in that 75th birthday conversation with Interview *magazine. She still had, all those years later, a copy of the book she had written at age 14,* Nibbles and Me, *and explained why that particular relationship had made such a mark: "I had let him loose in my room. And it was Easter. I had left a big chocolate Easter egg, opened, way up on top of a wardrobe at the house we were renting on the beach. I came charging into my room to get some dry clothes. The minute I came into the room, I'd*

always hear a clatter from wherever he was swinging and he'd come running up my leg. But there was no sound, there was nothing. I called and I called. I looked up at the wardrobe and there was the chocolate Easter egg, half gone, and there was Nibbles, dead, lying beside it with his little feet up in the air." Yikes. You finish reading that and wonder to yourself: Not sure if she could name her husbands in order, but there was this chipmunk that passed away 61 years prior. That's a woman who loves animals, and always has.

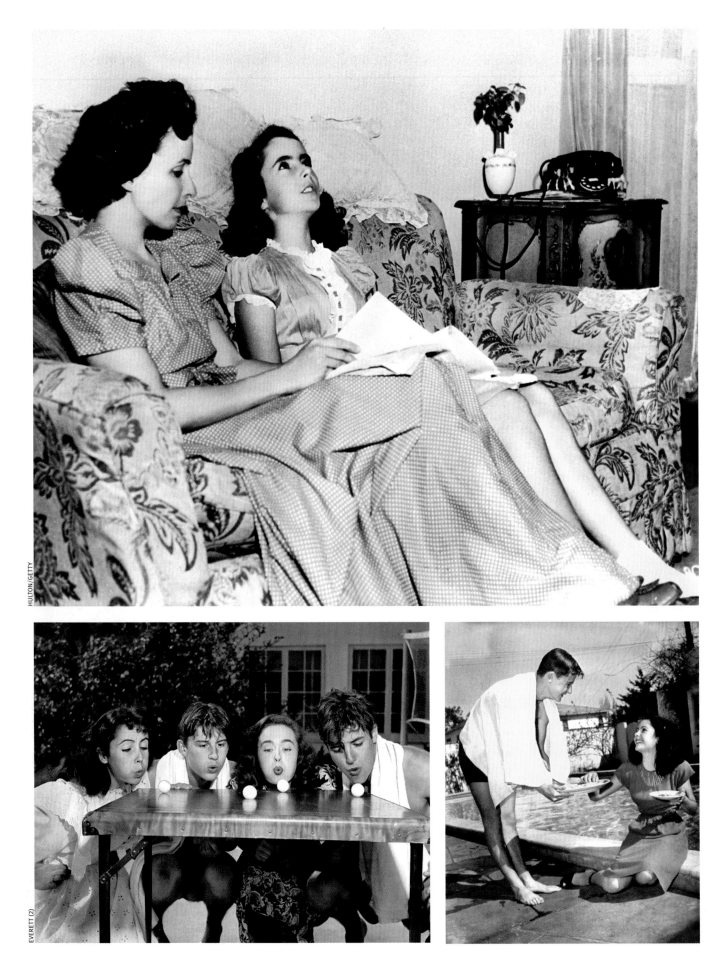

Opposite, clockwise from top: At home in 1946, working on homework of some kind, scholarly or professional; being served by fellow child star Roddy McDowall; goofing with fellow princes and princesses of Hollywood, from left, Liz, Roddy, Jane Powell and Richard Long. The director Joseph L. Mankiewicz would later say that Liz and Judy Garland were two he observed growing up in the movies who would forever have trouble separating the two realms, cinematic and life itself. He said they believed *what they did up there on the screen—believed that it represented some kind of reality. If Mankiewicz was in any way correct—and his conclusion is an easy one, perhaps even trite—then Taylor certainly, through the years, coped with adult celebrity and the disappointments of actuality with greater success than did Garland. She seemed ready for* real *stardom early on, and she rose to the role. As for the other "children" in these photographs, the chanteuse Powell—*Royal Wedding, Seven Brides for Seven Brothers*—and Long, who became known for TV's* The Big Valley, *certainly enjoyed Hollywood careers in their adulthoods, as did the English-born McDowall, one of Taylor's earliest costars and closest lifelong friends. He notably would play Octavian in* Cleopatra *and a heavily made-up simian in four* Planet of the Apes *movies. When he was dying of lung cancer at age 70 in his Studio City home in 1998, Elizabeth all but moved in to comfort him during his last days. As would be the case later when her friend Michael Jackson died, she grieved deeply but was reticent to share her emotions via extravagant statements or eulogies. Her personal relationships, though always public since "private" was impossible, would remain personal. She was complicated in this way: always out there, but at a certain point—a wall. Lastly: As for the dog on this page—more dog pictures!—this is her golden cocker spaniel Amy, named for her role in* Little Women, *a movie that would help send Elizabeth into the stratosphere.*

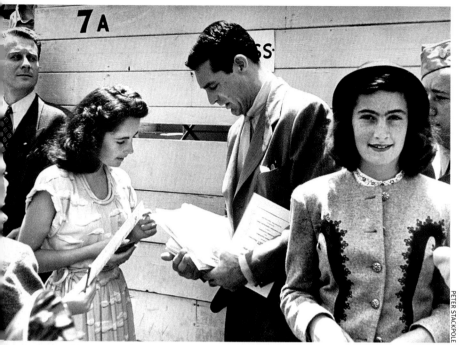

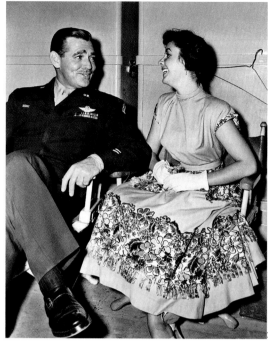

W as she already, as Hedda Hopper declared while Liz was 15, "the most beautiful woman in the world?" Well, quite quickly, she was among the most photographed, and whether in professionally made pictures or the most casual snaps—not to mention, in CinemaScope footage for the big screen— the camera adored her. On these pages we have photos from pros and from pals, both, as Liz segues gracefully from girlhood to womanhood. Above, left: She is seen by LIFE's Peter Stackpole at a cricket match with Britisher Cary Grant in the late 1940s. Above, right: She visits another first-string leading man, also destined to join her and Grant as an all-time Golden Age screen legend, Clark Cable, on a movie set in 1948. Left: That same year, Elizabeth, June Allyson and Janet Leigh wear their circa 1865 nightgowns, costumes for their roles in Little Women, during a lunch break in the studio commissary. The legend goes that whenever Liz walked into the cafeteria— not in this nightgown, necessarily, but however garbed—a hush fell over her fellow movie folk as they watched this beauty make her way to the table. One day, a boisterous fellow shattered the quiet by bellowing with great good humor, "How did she ever get into the movies?!" How indeed, as evinced on the opposite page, where Liz and her good friend Jane Powell are two bathing beauties enjoying an afternoon off on a California beach, also circa 1948.

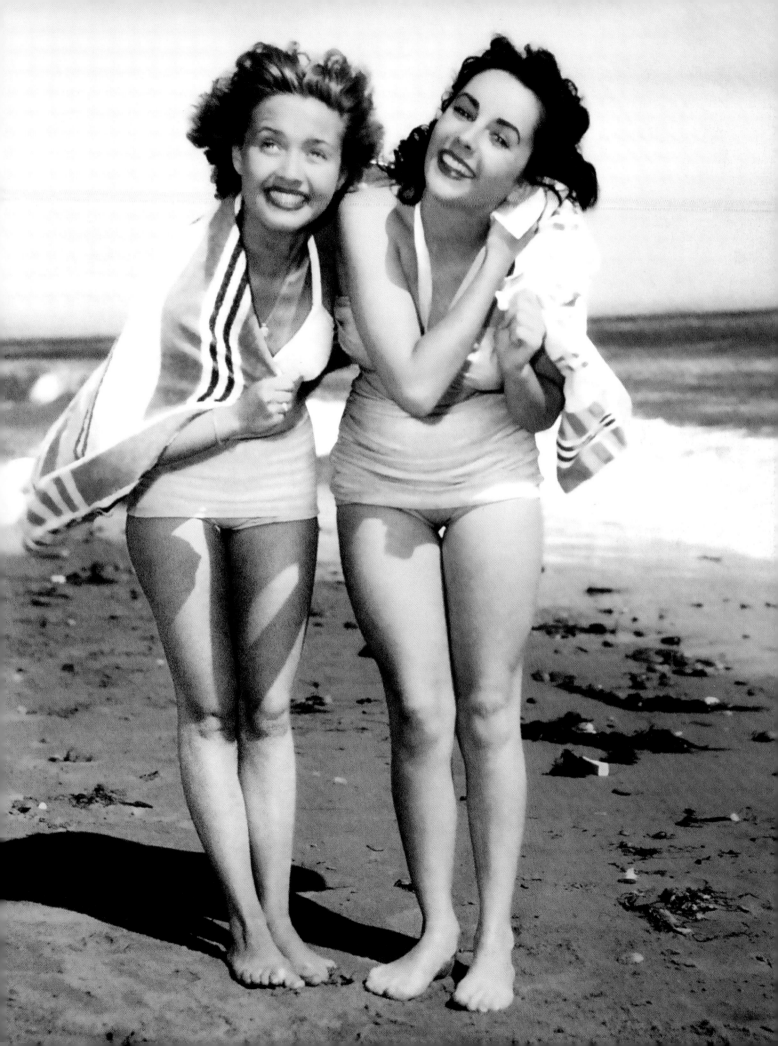

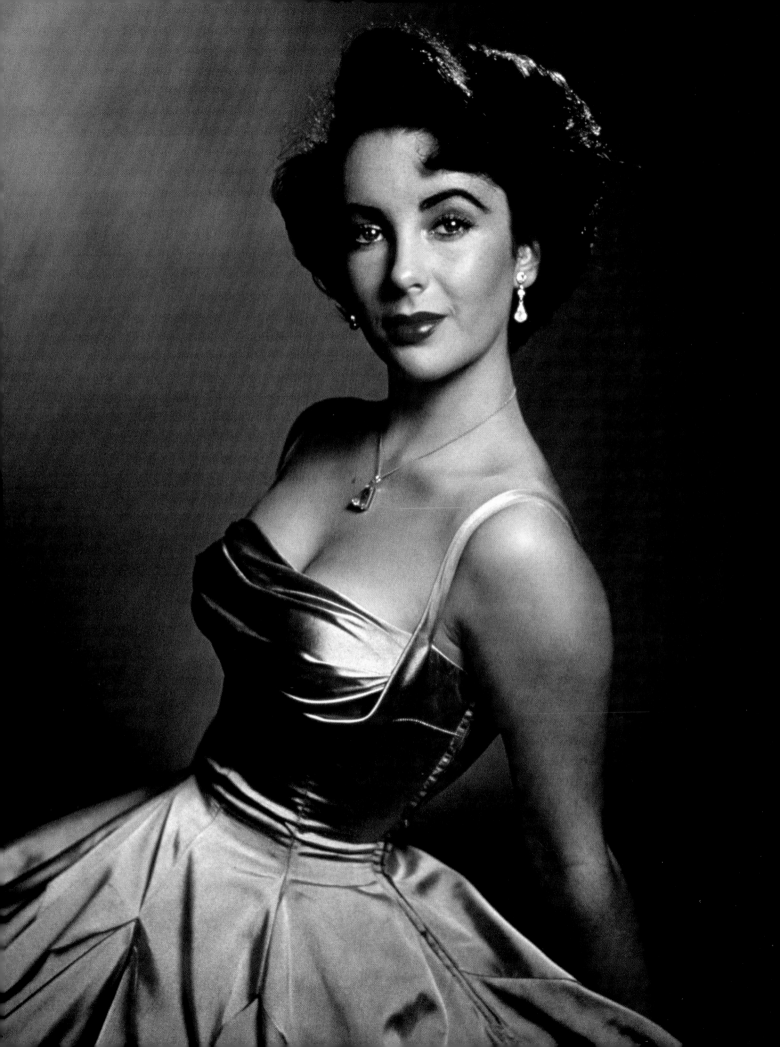

Queen
of
Hollywood
(Soon, the Nile)
1948–1962

ELIZABETH TAYLOR, IN HER CHILDHOOD AND ADOLESCENCE, HADN'T shown any signs that she was a diva in progress. At MGM the kid was known as One-Shot Liz for her ability to pay attention and nail a scene in a single take. When *Time* magazine featured a host of Hollywood hopefuls who were poised on the cusp of true superstardom—Montgomery Clift, Kirk Douglas and Shelley Winters among them . . . as well as Ruth Roman, Audrey Totter and John Lund—the magazine observed: "Elizabeth's womanly beauty usually makes strangers forget that she is, after all, only a youngster, but her behavior quickly reminds them of it. Beneath her breath-taking façade there is scarcely a symptom of sophistication." So she was a lovely, agreeable, compliant teenager. Yes? Or was the next sentence an augury? "But Elizabeth, for all her youngish ways, is a purposeful girl in a way that Hollywood admires: she is feverishly ambitious to make a success in pictures."

Hedda Hopper, who after the early introduction had become a friend of the Taylors, had lately made that declaration that Elizabeth, at 15, was the most beautiful woman in the world—something Liz was starting to hear with regularity. One day an MGM photographer said to her, "I thought you'd like to know that the boys have voted you the most beautiful woman they have ever photographed." At which point Elizabeth turned to Sara and gasped, "Mother, did you hear what he said? He called me a woman!"

All of this sudden attention, even adulation, would go to anyone's head, and it certainly went to Elizabeth Taylor's. Starting with *Cynthia* and continuing through *Little Women, Father of the Bride* and *A Place in the Sun,* she developed a reputation as an actress who needed special handling.

In 1948, LIFE sent the great portraitist Philippe Halsman to prove that Elizabeth Taylor was ready for her grown-up closeup.
She surely was a Sweet Sixteen.

Sometimes, the label "demanding" can be the kiss of death in the movie industry, where everything is moving fast and deadlines are tight. But such stars as Taylor and, to a much more egregious degree, Marilyn Monroe simply cannot be denied. They are too valuable. *Time* recognized this about Elizabeth early on, when they put her on the cover of that issue about Hollywood's aspirants and wrote: "Every day the maw takes a bite or two of common clay, lugs it off to Hollywood's casting mills. There it is sifted for the sapphires that men sometimes find in common clay . . . MGM has already turned up a jewel of great price, a true star sapphire. She is Elizabeth Taylor.

"At 17, 5 foot 4 ½ inches, 122 lbs., Elizabeth Taylor is a great beauty. She is a perfect type of the Black Irish. She has heavy black hair and brows that are also black and thick, but not a whit too thick to frame her large, luxuriantly lashed blue eyes, which darken into violet in the least shadow. Her complexion has been described by an ecstatic publicity man as 'a bowl of cream with a rose floating in it.' Cameramen have paid her Hollywood's ultimate compliment to beauty: 'She doesn't have a bad angle.'

"In Hollywood, which has long since proved its theory that even a flea can be taught to act a little, Elizabeth Taylor is a sure star of the future."

Yes, she was, but regardless of the condescension in that last sentence, she had talent as well, as she proved early and then often. It would take a while for critics and even audiences to seize upon this point as her astonishing gorgeousness overwhelmed all. If Taylor minded this ("If you were considered pretty," she said, "you might as well have been a waitress trying to act— you were treated with no respect at all"), the studio certainly didn't, and early in the star's adult career, MGM happily played the sex card. Again from *Time* magazine, in 1949: "As Elizabeth ripened, MGM ripened her roles. In *Conspirator*, not yet released, Robert Taylor (no kin) made love to Elizabeth so fiercely (said Hedda Hopper) that one of her vertebrae was dislocated. Next

year Elizabeth will get an even juicier part in Theodore Dreiser's *An American Tragedy*. She will costar with Montgomery Clift.

"Metro's publicity men have not missed many bets. In July of last year, West Point's All-America Glenn Davis was brought by some friends to the Taylors' house at Malibu Beach. When infantryman Davis appeared, Elizabeth looked up 'and I thought: O ye gods, no! . . . He was so wonderful!'

"Cinema columnists duly reported the state of Elizabeth's wonder, followed the romance play by play. Glenn gave her his gold football, his All-America sweater and finally, Elizabeth said, his troth, effective in three years, some time after his tour of duty in the Orient.

"For months there was nobody quite like Glenn. Even Prince Philip, whom Elizabeth met in London, could not undo the gift-wrapping on her heart. 'English girls think he's so good-looking,' hummed Elizabeth. 'I guess our standards are just different.'"

Whether the Glenn Davis and Prince Philip flirtations were wholly manufactured by or just encouraged by studio flaks, these swains were soon gone with the wind (Philip had to start courting Princess Elizabeth, the future queen of England, after all). Similarly fleeting was a relationship with William D. Pawley Jr., the 28-year-old son of a former U.S. ambassador to Brazil. Elizabeth claimed she was sure they would wed, and said she was actively scouting places in California in which to settle: "I've seen several houses and they're all just the darlingest things." As it eventuated, Bill Pawley did not turn out to be Husband Number One. The hotel scion Conrad "Nicky" Hilton Jr. did. Elizabeth met the high-rolling Hilton at the Mocambo nightclub in L.A. in October 1949, when she was 17 years old. They were engaged just as she was turning 18 the following February, Nicky placing a four-carat square-cut diamond on her finger—stoking those jewelry fires that would burn a lifetime. They were married, with 3,000 fans gathered outside the Beverly Hills church and 700 guests at the Bel Air Hotel reception.

In 1951, Elizabeth smiles for the camera. The previous year she had scored her first adult box office hit in Father of the Bride, *quickly followed in '51 by the sequel,* Father's Little Dividend.

BOB WILLOUGHBY

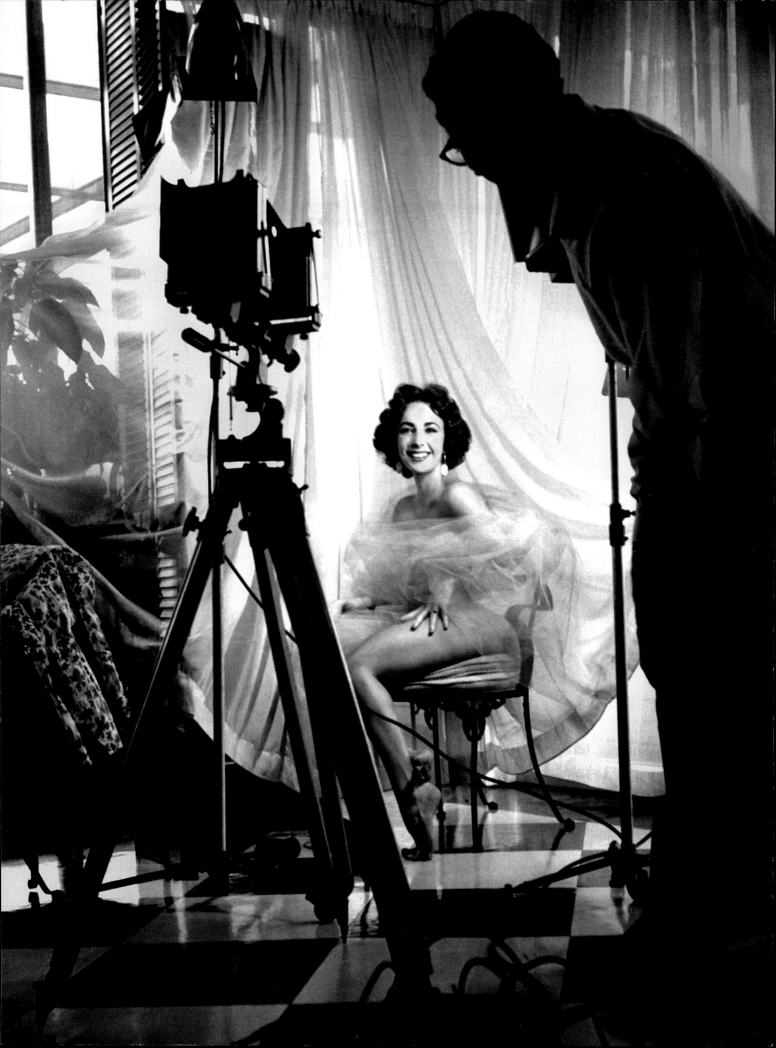

In May 1951, Elizabeth conceded to Hedda Hopper, "After a month of our wedding I knew we'd made a mistake"—but she stuck it out for 205 days.

Was it too soon in her marital career to conclude that Elizabeth Taylor was impulsive in love and perhaps too quick to say "Yes"?

Well . . .

In February of 1952, the dust of the Hilton affair still settling, Taylor wed Husband Number Two, the British actor Michael Wilding, in London. This union, which would last until 1957 and produce two children before ending in a quickie divorce in Acapulco, must be deemed one of her most successful.

Even as she was grabbing headlines on the gossip pages, she was successfully making a remarkable transition from child star to film star in the Arts section, somehow skipping the starlet stage altogether. In 1951, *A Place in the Sun* was released, and as A.H. Weiler wrote in *The New York Times*, "Elizabeth Taylor's delineation of the rich and beauteous Angela . . . is the top effort of her career." She was now an actress to be not only longed for but reckoned with, and yet her next little string of films were forgettable. Then, beginning with *Giant* in 1956, she went on an extended winning streak, with Best Actress nominations for *Raintree County* (1957), *Cat on a Hot Tin Roof* (1958) and *Suddenly, Last Summer* (1959). Her accompanists in these pictures included Montgomery Clift (twice), Paul Newman and Katharine Hepburn, but top billing usually went to Taylor. She was the queen of Hollywood.

While we're on the subject of queens: In 1960, she signed a contract with 20th Century Fox to portray Egypt's Queen Cleopatra. She would be paid the astonishing sum of a million dollars. In November of that same year, she starred in the film adaptation of novelist John O'Hara's *BUtterfield 8,* about a prostitute with a conscience and a last chance at a good man. "By the odds, it should be a bomb," wrote Bosley Crowther in his *New York Times* review. "But a bomb it is not, let us tell you. At least, it is not the sort of thing to set you to yawning and squirming, unless Elizabeth Taylor leaves you cold.

"In the first place, it has Miss Taylor, playing the florid role of the lady of easy virtue, and that's about a million dollars right there. 'I was the slut of all times,' she tells her mother in one of those searing scenes wherein the subdued, repentant playgirl, thinking she has found happiness, bares her soul. But you can take it from us, at no point does she look like one of those things. She looks like a million dollars, in mink or in negligee." Clearly, the million-dollar contract had made an impression on the culture beat. But more important: Taylor went on to win her first Academy Award for Best Actress in a Leading Role for *BUtterfield 8.*

One of her costars in that film was the singer Eddie Fisher, who was at the time Husband Number Four. Number Three, following her divorce from the actor Wilding, had been Mike Todd, the Broadway impresario turned Hollywood mogul, whom she considered, upon marrying him in 1957, "the most exciting man in the world." Taylor, who had been born a Christian Scientist, was convinced to convert to Judaism by Todd, who had plied her with jewelry and been an insistent suitor. ("Don't start looking around for someone to latch on to," he told her early on. "You are going to marry only one guy, and his name is me." Said Taylor later: "He didn't ask me. He told me. He was irresistible.") For private entertainment during their honeymoon, the flamboyant Todd hired a ballet company.

On March 21, 1958, the always on-the-go Todd left California to attend a dinner in New York, where he would be feted as Showman of the Year. His personal two-engine plane, the *Lucky Liz,* ran into a terrible storm in the middle of the night over New Mexico's Zuni Mountains, and its wreckage was found the next day in an alpine valley.

Taylor's marriage to Todd might today be remembered as her most interesting, dramatic, exciting and passionate . . . But she was about to run into Richard Burton.

In 1959, Elizabeth films Suddenly, Last Summer. *So astonishing was her physical beauty in this period, it took some time for critics and audiences to appreciate her deep acting talent.*

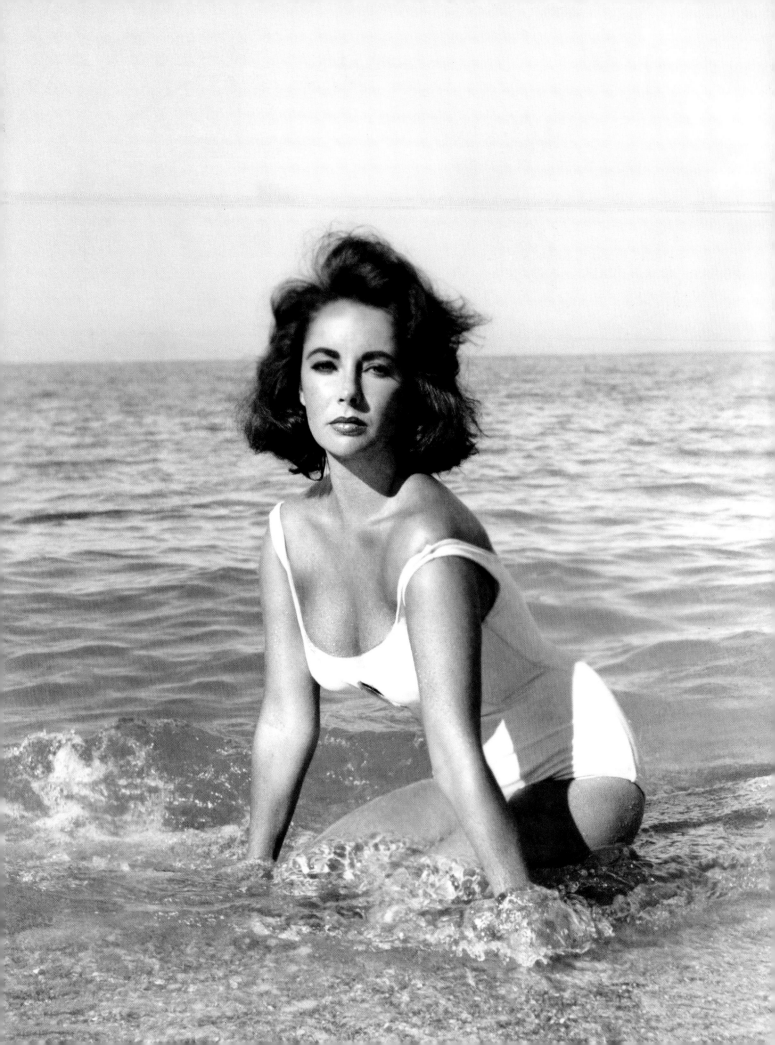

L IFE *dropped in on the Taylors again in 1948, documenting a luxurious home life (opposite, Sara and her daughter outside the family manse) and Elizabeth diligently at work on her studies, as well as on her screenplay lines. Counterclockwise from left: Mother and daughter confer; Liz in a classroom on the MGM lot; and Liz upon graduating from the studio school in 1950. She wouldn't attend college, but even without it she built a remarkable, somewhat hilarious educational résumé: The tony Byron House school in the Highgate section of London; Willard Elementary in Pasadena, California; Hawthorne Elementary in Beverly Hills; the Universal Pictures schoolroom; and MGM's storied Little Red Schoolhouse in Culver City, where all of those kids in the multitudinous Metro musicals and family-fare flicks were educated (or not). Elizabeth, smart as a whip and canny—as she would prove throughout her life—was destined to get her diploma through no fault of her own. As* Time *magazine reported in 1949, when she was entering her senior year at the Schoolhouse: "Elizabeth has only a little temperament and almost no side; she pretends to no more learning than she needs, reads little besides movie magazines, hates school, loves ice-cream sodas, convertibles and swimming pools, and admires big strong men." Admires them only too well, as she would shortly prove with a man who would exercise his strength by beating her.*

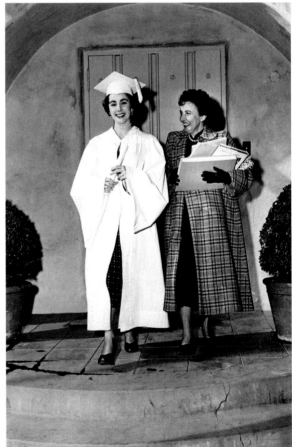

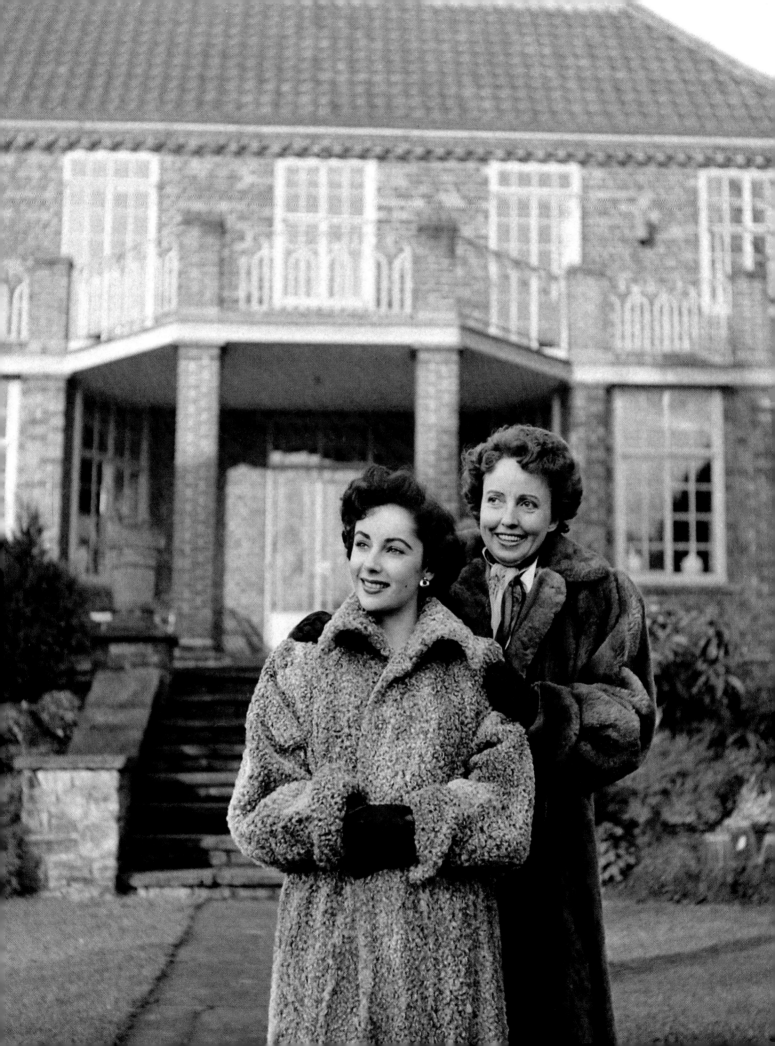

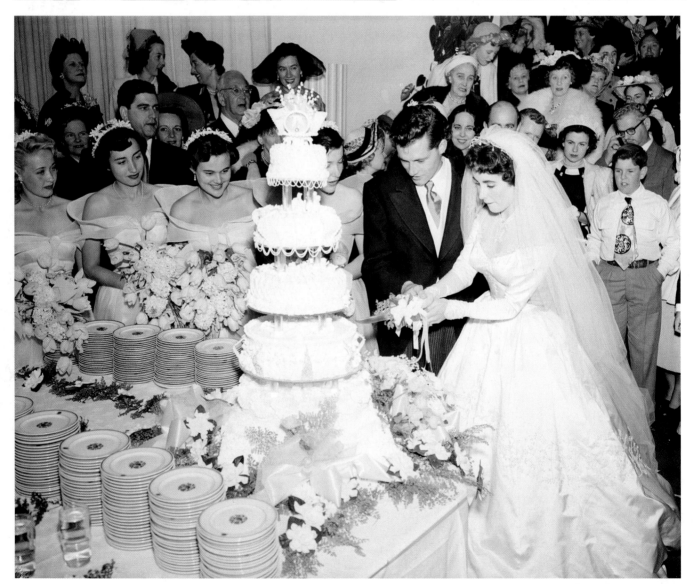

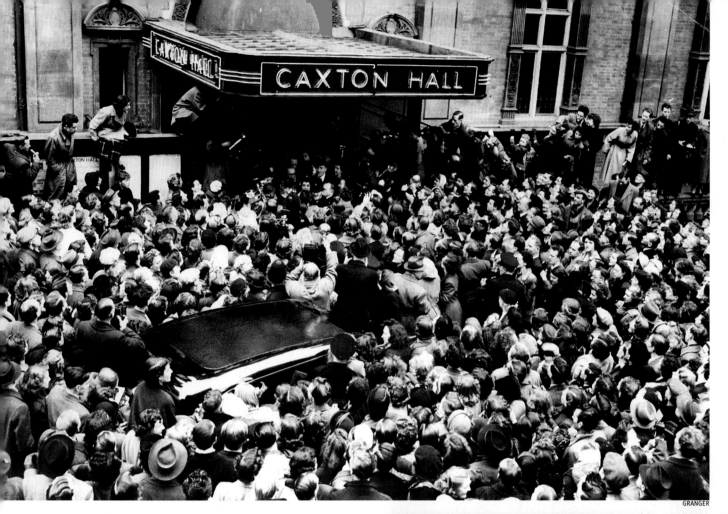

I n late June of 1949, right after Elizabeth's junior year in high
school came to a close, mother and daughter flew to Miami and
stayed at the home of the Pawleys, whose son, Bill Jr. (opposite,
top left, with Liz during that very visit) was a man of whom Sara
excitedly approved. Before the Taylors broke camp in Florida, an
engagement was announced. It wouldn't lead to marriage however;
if it had, Liz might have been luckier. The wedding bells begin to
chime for her (they would rarely be stilled) when Liz weds Conrad
Nicholson Hilton Jr. on May 6, 1950, in Beverly Hills (opposite,
bottom). In the photo at top right, Francis and Sara Taylor arrive
for their daughter's wedding—something that will become a ritual.
Also in attendance this day is the va-va-va-voom film star Zsa Zsa
Gabor, who had been Nicky's stepmother before divorcing from
Conrad Hilton Sr. We note Zsa Zsa's presence so we might explain
just how bizarre the Hiltons' world was, even in generations
before our contemporary Paris. Gabor shows up and evinces no
awkwardness, even though she knows full well that she had slept
with her stepson when she was still married to his father. Ah, but
nothing can spoil Liz and Nicky's happy day, and soon they are
honeymooning in Europe for three months, not needing to bother
over reservations when checking in at a Hilton. Although Liz and
Dick would be known as the Battling Burtons, the appellation was
metaphorical—at least when it came to physicality. Nicky Hilton,
an unstable man with a drug and alcohol problem, actually hit her,
and the marriage was over in a year. Next up was a more successful
union with actor Michael Wilding. On this page: Three thousand
fans storm the Caxton Hall registry in London on February 21,
1952, when the stars wed there in a civil ceremony, and bobbies are
forced to intervene.

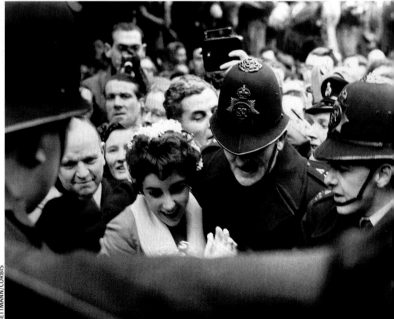

Below: In September 1953, Elizabeth hands over her first baby, Michael Howard Wilding, to a personal nurse while she and her husband tour Europe. At right, she is at home with Wilding, relaxing and having sport, knowing full well that these photos are destined for the magazines—and her millions of fans. In pictures such as the ones on these pages, everything seems gay and light, and like something approaching normal, despite perhaps the symbolic horns. But normalcy was utterly unattainable in Hollywood's Golden Age. Wilding is a case in point. In aspect, and with his dapper Britishness, he looks like a staid, stable counterpoint to his glamorous young wife, 20 years his junior and only 21 years old. That he had a successful career in films made in England while struggling in Hollywood only adds to the impression. But consider: He married four times himself, and almost immediately upon divorcing from Taylor in 1957, he showed up with the singer/model/gossip-column-superstar Marie "The Body" McDonald on his arm. The Body would herself marry seven times and count as other paramours the gangster Bugsy Siegel and the Liz Taylor—husband-to-be Eddie Fisher. And we have already recounted Nicky Hilton's wife-beating, and his reckless relationship with his stepmom. The circles that these people traveled in, the lives that these people led, were beyond the reckoning of most "normal" folk. And so the facts were hid from view, as best they could be hid, and the fantasy of "the neighbors" was sold wholesale.

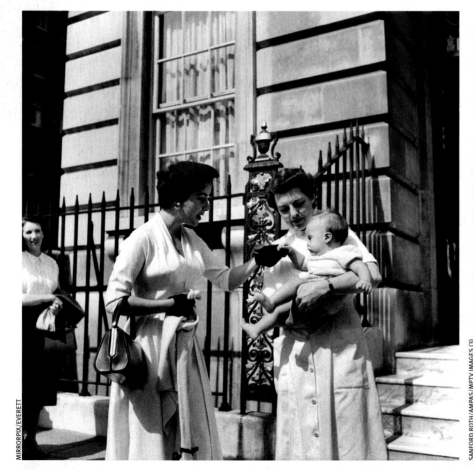

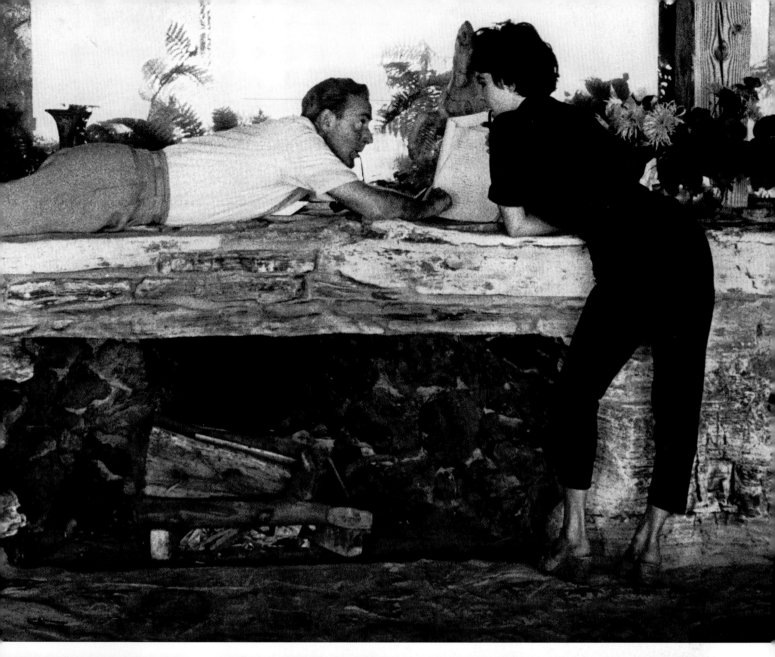

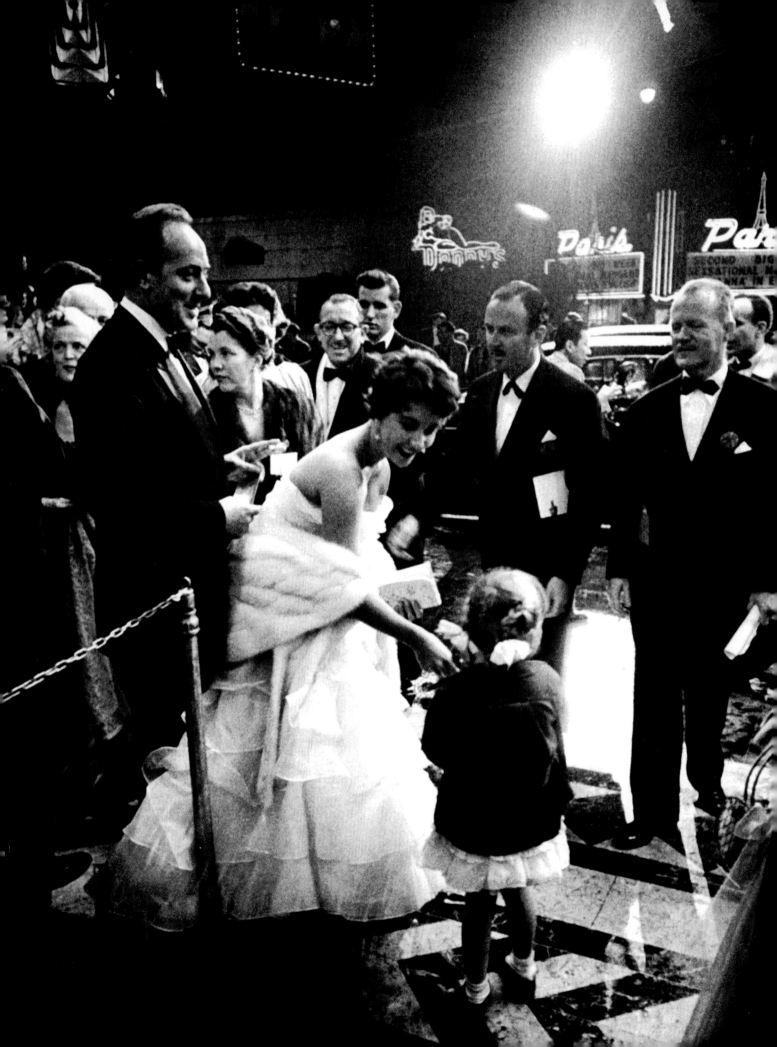

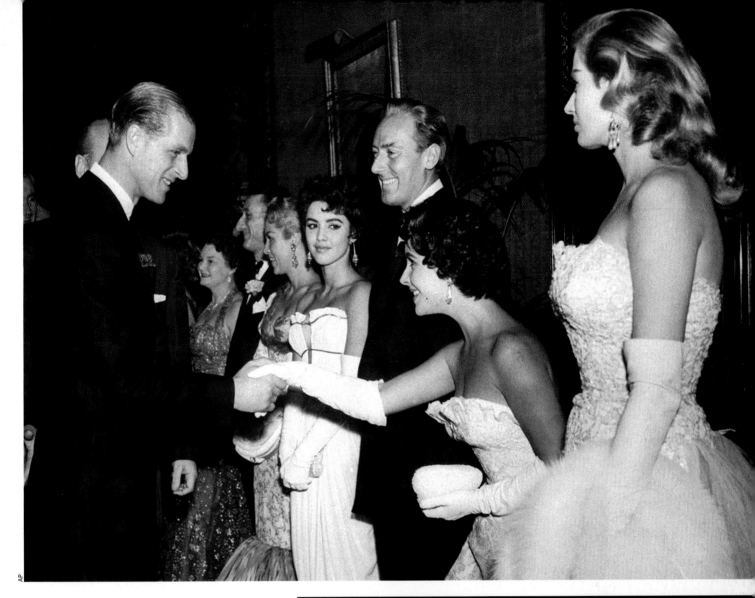

*O*pposite: *Elizabeth signs an autograph for a little girl before proceeding into the RKO Pantages Theatre at the corner of Hollywood and Vine for the 25th annual Academy Awards ceremony in 1953; hers is an intimacy that is a far cry from today's telecast red carpet. Above: She curtsies as she is greeted by Prince Philip, Duke of Edinburgh, at the premiere of* The Cockleshell Heroes *at London's Empire Theatre on November 23, 1955. Wilding, beside her, is unworried about Philip's intentions as the prince is, by now, married to Queen Elizabeth II. It can be said that Taylor belonged to three countries: Hollywood, the United States and Great Britain. She was always at home in England, never more so than during her first seven years in London and then again during her marriage to Wilding. As for her status in Hollywood, she was, in the late 1950s, as close to an uncrowned queen as it was possible to be. Right: With old family friend and perpetual booster Hedda Hopper during a break in the filming of* Giant *in 1955, she talks about where she once was, and where she is now. It all should be seen as "unbelievable" by anyone's measure, but it is apparent that Liz believed it from the start.*

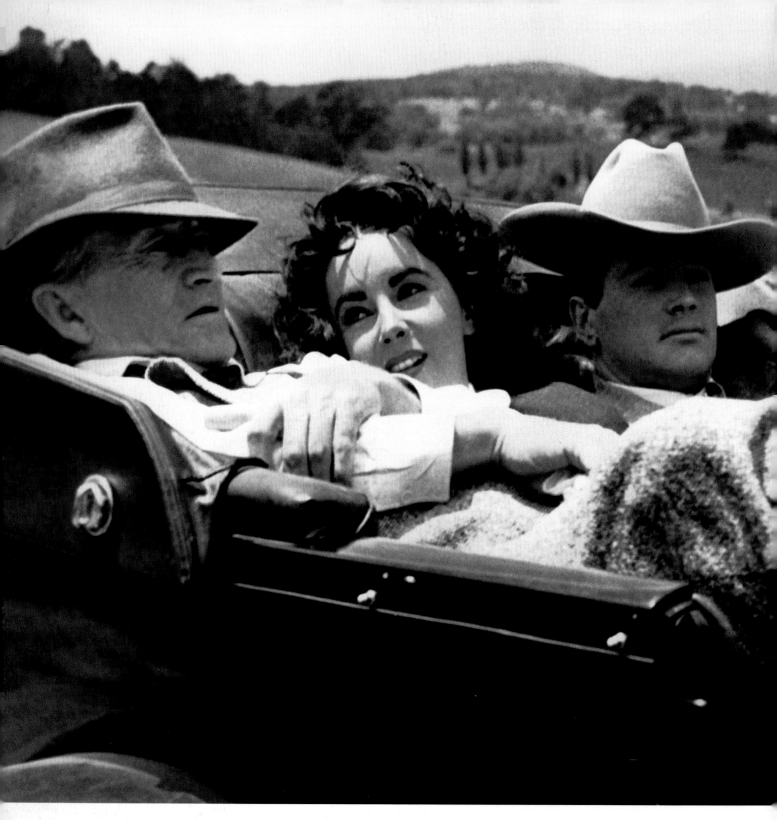

The Texas ranch epic Giant *was enormous in Elizabeth Taylor's career, and in her personal life, for on this production she would meet Rock Hudson, yet another male actor who would become a devoted friend. Their relationship started on the set with introductory cocktails, which continued to be poured and quaffed until 3 a.m., at which point both actors were plastered. They were wakened at 5:30 to shoot a wedding scene that involved—thank goodness—no dialogue. Each focused intently on not appearing to be sick or hungover, but rather very much in love, and they must have been convincing as some in the production crew* began to weep. Director George Stevens (relaxing on the set with Taylor and Hudson, above), who would win an Oscar for Giant, had worked with Liz on the 1951 success A Place in the Sun and trusted her dedication to craft. Therefore, he had already willingly delayed Giant's start so that Elizabeth could give birth to her second son, Christopher Edward Wilding, on February 27, 1955, and he looked the other way when she and Rock (seen, opposite, with Liz in informal pictures from the set) showed up for work slightly the worse for wear. But, as we shall learn on the following pages, even when things went well for Liz, there was human drama.*

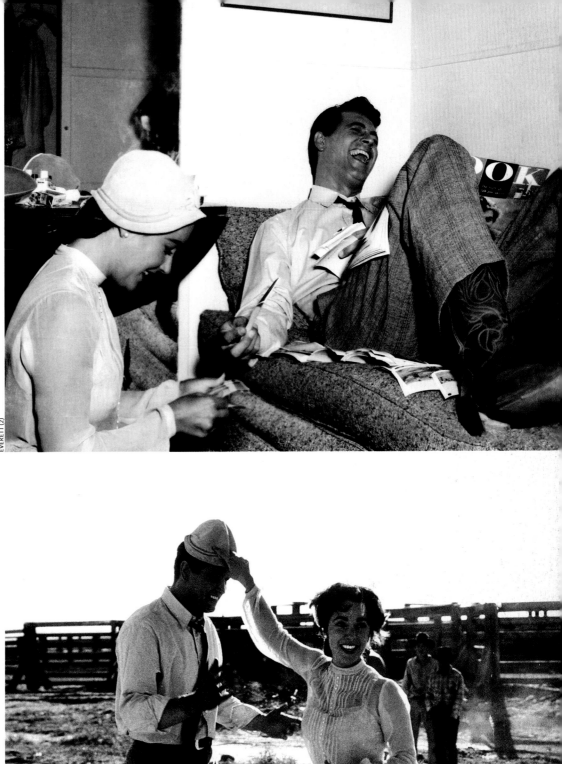

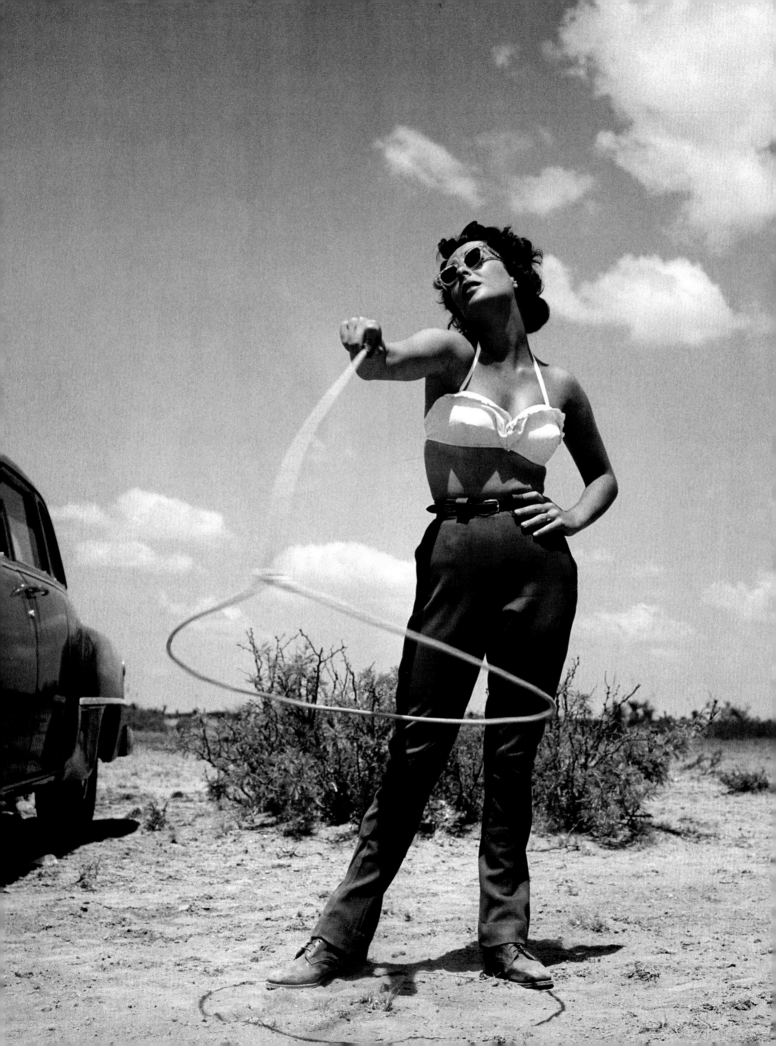

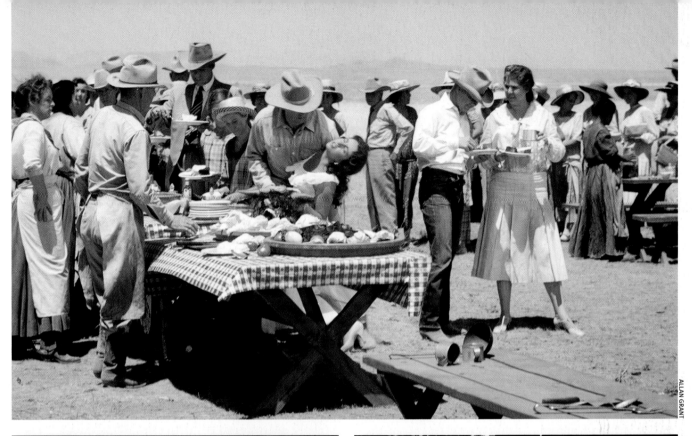

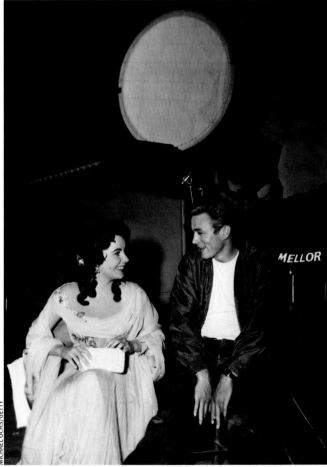

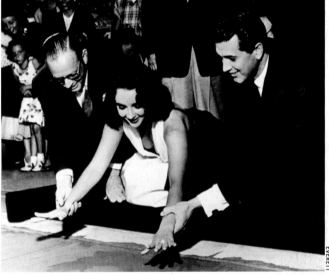

Giant *steps: For Rock Hudson, James Dean and Elizabeth Taylor, the movie* Giant *cemented their places in the Tinseltown pantheon. For Rock and Liz, literal cement was involved as they performed the Hollywood ritual of immortalizing their handprints outside Grauman's Chinese Theater (above). By this point, Dean was dead: He had been killed in a car crash in California before production had finished. He is seen at left in 1955 with Taylor during the shoot, wearing his jacket from* Rebel Without a Cause, *the second of three films (including* East of Eden*) that constitute his short, legendary oeuvre. So distraught was Liz when she learned of Dean's death, she asked for a day's moratorium from filming for the cast, a request that was denied by director Stevens. At top is the famous barbecue scene in a color rendering, rare for the time, by* LIFE's *Allan Grant. Opposite: Liz, horsing around during filming in the Southwest. The sprawling* Giant *was shot in Hollywood and on location in Virginia, Arizona and Texas.*

41

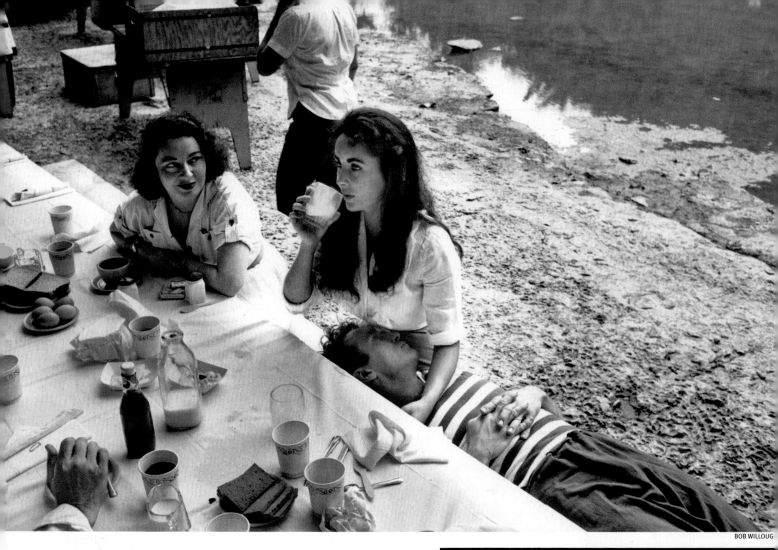

In 1956, Taylor filmed Raintree County, a Civil War–era film that would lead to her first Best Actress nomination. Her costar in the movie was her friend Montgomery Clift, seen here several times with Liz, at the height of his career; he was, in fact, billed over Taylor in this case. On May 12, 1956, Liz and her husband, Michael Wilding, threw a party at their Coldwater Canyon home, and while driving home Clift crashed his car into a telephone pole—less than a year after James Dean had died in similar violence in California. Taylor rushed to the scene of the accident, and cradled Clift, perhaps saving his life when she pulled a tooth from his throat as he was gagging on it. The car had been totaled and the supremely handsome Clift was a thorough mess, though plastic surgeons did what they could. The actor eventually returned to work and finished the film, which was a hit, but residual pain from his injuries led to drug and alcohol abuse, and thus began what is called "the longest suicide in Hollywood history." He died a decade later at 45 years of age. A few final notes about these pictures from happier days: The sequence opposite was made for LIFE by Peter Stackpole, who as we know had been shooting Liz since she was barely a teenager. The photographs on this page from the set of Raintree County, including a cute one of Monty taking his rest with Liz during a lunch break, were made by the noted Hollywood photographer Bob Willoughby, whose body of work on his close friend Audrey Hepburn was collected in the LIFE book Remembering Audrey. On the pages immediately following: Everything changed for Clift with Raintree County, and Taylor, too, went in a different direction; by the spring of 1957, she was at the Cannes Film Festival with third husband, Mike Todd. In this lovely shot, she and her boys are out enjoying the fresh Riviera air in Nice.

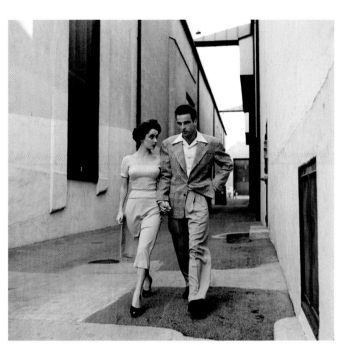

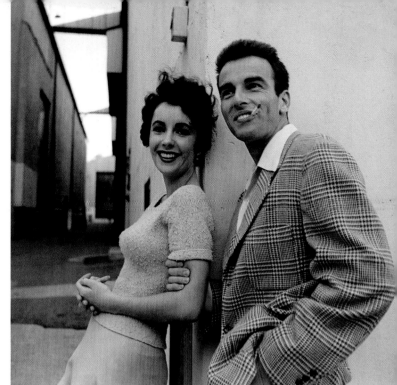

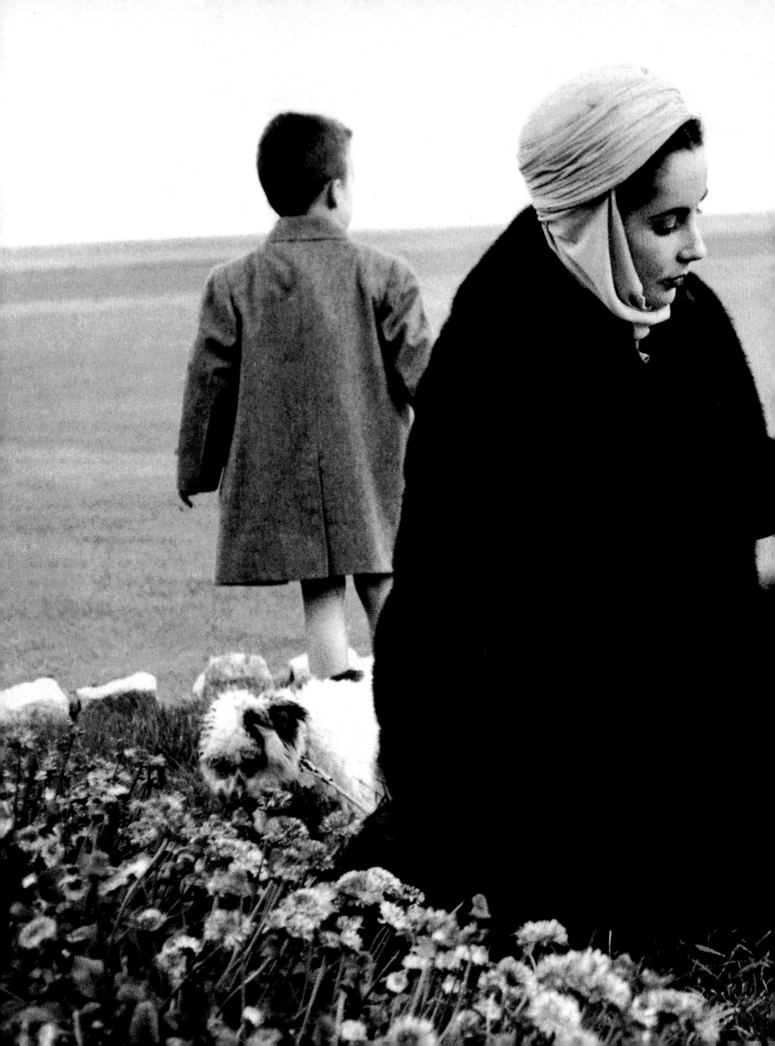

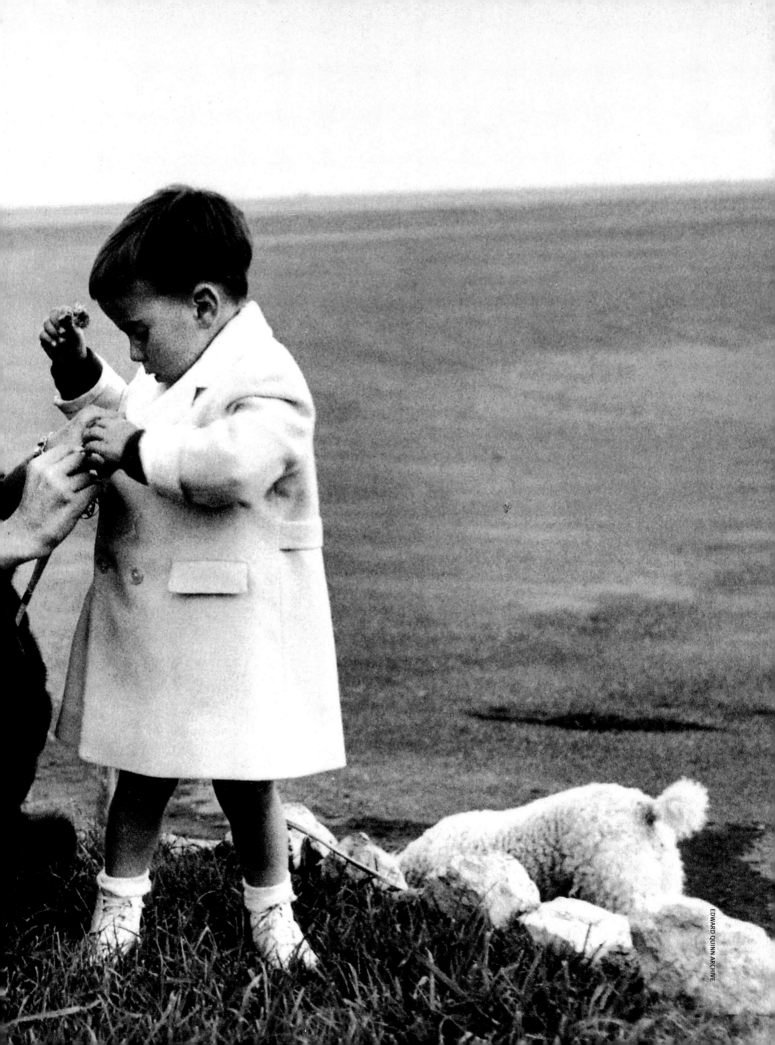

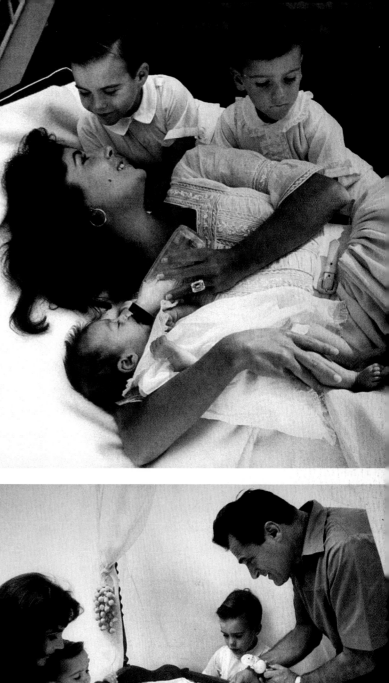

Portrayed here: Mike Todd, American Dad. Taylor's courtship by the larger-than-life impresario Todd and her marriage to him were fast-paced, flamboyant, full of life; she has said that of her many marriages, this one, despite its tempestuous episodes (and they certainly qualified as tempestuous), was the "happiest." They married in February 1957 and welcomed daughter Elizabeth "Liza" Todd, seen on these pages with Elizabeth's sons by Michael Wilding, in August. Todd was a powerful, some might say domineering, man. He had been born into poverty in the Midwest, had made and lost a fortune in real estate, had become rich again as a producer, first with stage shows and then most memorably with the extravagant film Around the World in 80 Days, which cost $6 million to make in 1956 and went on to earn many multiples of that at the box office, meanwhile taking home the Academy Award for Best Picture (beating Giant, among other finalists). In March 1958, Todd dissuaded Liz from traveling with him in his twin-engine airplane from the West Coast to the East because of her nagging cold, but he tried to coax a pal aboard for a game of gin rummy: "Ah, c'mon, it's a good safe plane. I wouldn't let it crash. I'm taking along a picture of Liz and I wouldn't let anything happen to her." On the Lucky Liz with Todd when it went down in the early morning of March 22 was the writer Art Cohn, who was working on a biography, The Nine Lives of Michael Todd. There would not, of course, be that many.

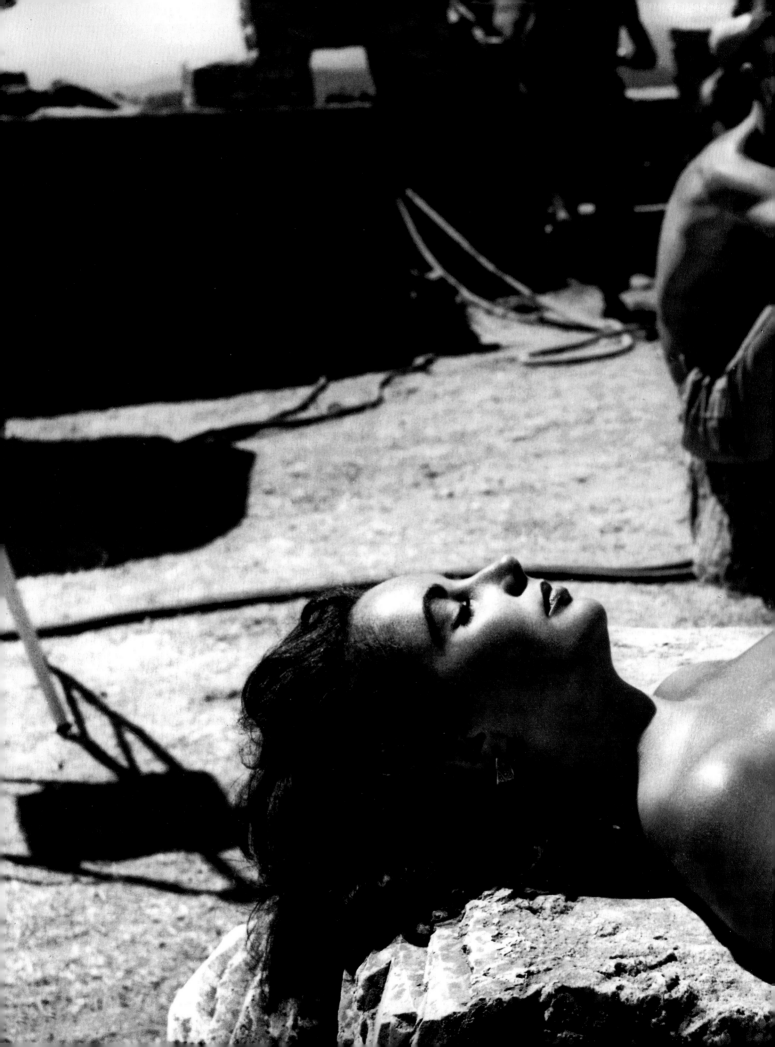

After Todd's death, Taylor's return to moviemaking was marked by what can be called her Tennessee Williams period—two big films, for which she is remembered today. This sunbathing picture of the world's greatest-ever sunbather was made in 1959, in Sagaro in the north of Spain, on the set of Suddenly, Last Summer, *a hot movie (the tagline· "These are powers and passions without precedent in motion pictures") that was largely shot in chilly, dreary England. Liz's colleagues on the film included costars* Montgomery Clift and Katharine Hepburn, director Joseph L. Mankiewicz *and coscreenwriters Williams and, of all people, Gore Vidal. The shoot was not without problems; in particular, the producer Sam Spiegel and Mankiewicz were said to have treated Clift, who was by now struggling with his addictions, poorly. Hepburn, who thought she too was being maligned, and Taylor stuck up for their friend and fellow actor, and the legend goes that when Hepburn's final take was finished, she spat in the face of Spiegel and left the set. (An alternate version has her spitting at Mankiewicz, and a second variation says she targeted both men.) Interestingly for these two sisters-in-arms: This was the one time in either Hepburn's or Taylor's career that they would compete with a costar for the Best Actress Oscar. In the finals, as it happened, both lost out to Simone Signoret, who was admittedly sensational in the English film* Room at the Top. *With* Suddenly, Last Summer *and with Taylor's next few big ones, and her increasingly noteworthy personal life, she so distanced herself from the days when she was a little woman that her fans could scarcely believe that this forceful, dangerous woman had once been that fresh-faced, sweet kid.*

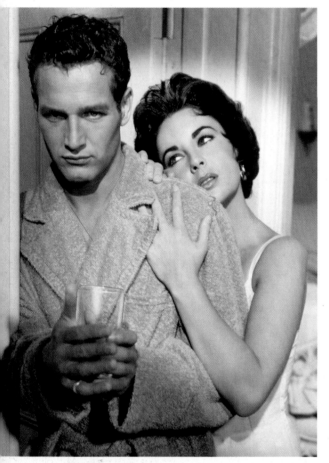

L iz had even greater success in another adaptation of a Williams play, Cat on a Hot Tin Roof, *costarring with Paul Newman (left). Here's a fun fact to know and tell: The film was scheduled to be shot in black and white, since it was perceived to be artsy. But when Taylor and Newman were cast as the leads, the very artsy director Richard Brooks felt that he had no choice: The audience wanted—needed, required—her violet eyes and his of sparkling blue. Color film was ordered in quantity. Liz's movie career thus remained on the fast track, and meanwhile, of course, the matrimonial train chugged along strongly, but not without hair-raising moments. The photographs on these pages document Elizabeth's first major and painful tabloid scandal, and set the stage for a scandal to come. At bottom: Eddie Fisher, Taylor and Todd at dinner in 1957. These three are all red-hot in showbiz, Todd having won Best Picture for 1956's* 80 Days, *Liz coming off '56's* Giant *and Fisher having enjoyed a bundle of pop hits in the last six years plus a popular 1956 romantic comedy film,* Bundle of Joy, *alongside his wife, Debbie Reynolds. Below are Liz, Eddie and Debbie. Now then: A year after Todd's death, Taylor married her deceased husband's pal Fisher (opposite). The story goes that Debbie and Eddie, filmdom's favorite couple—America's sweethearts—were all lovey-dovey until their dear friend Mike died cruelly, and Debbie sent Eddie to console Liz. He never came home.*

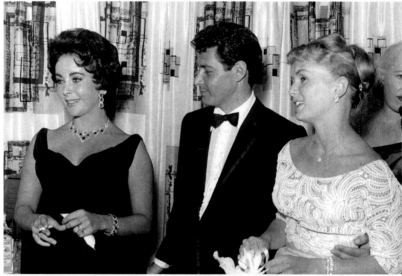

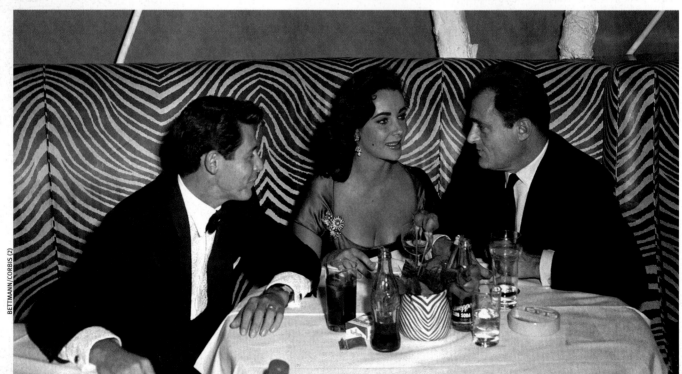

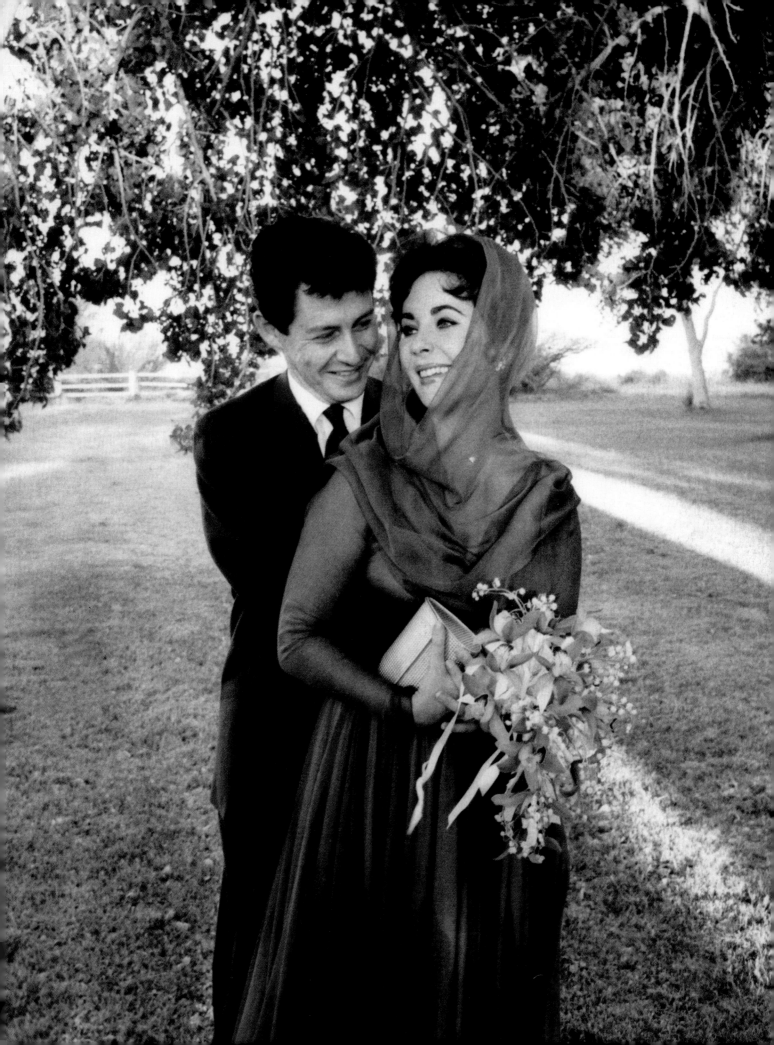

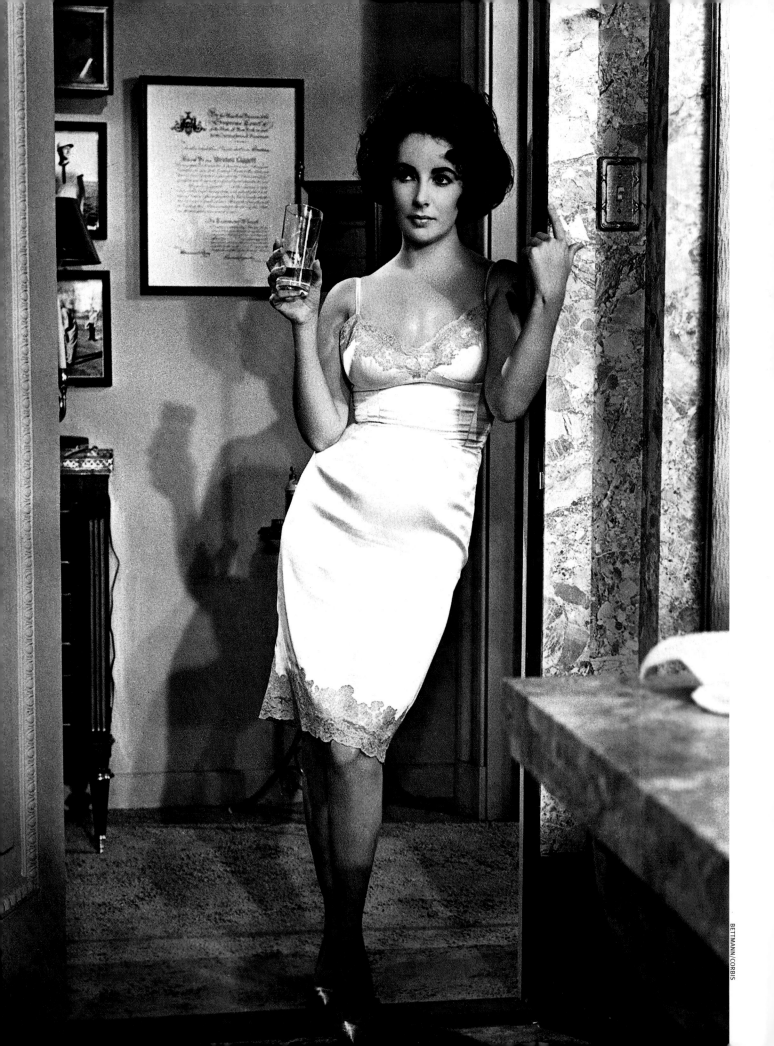

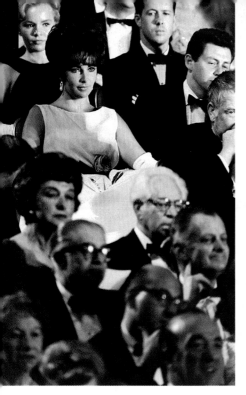
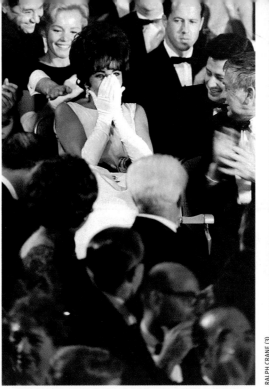
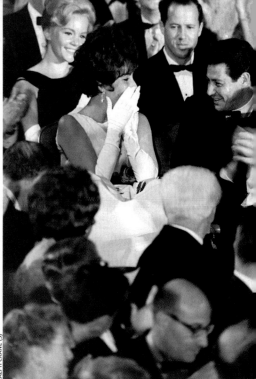

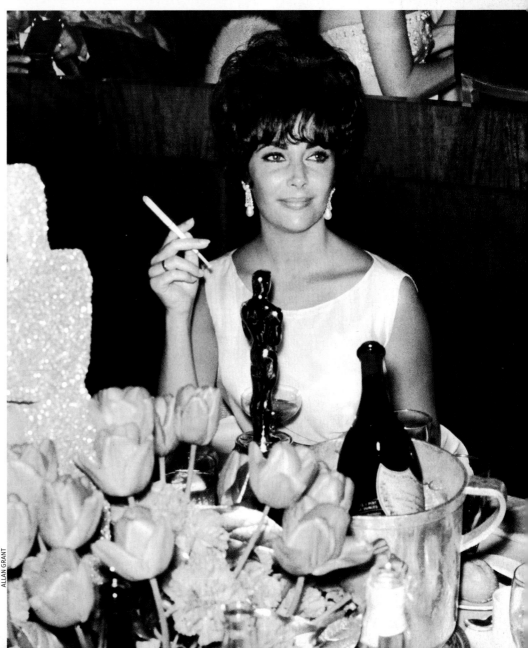

Opposite: Elizabeth as the call girl in the film adaptation of John O'Hara's BUtterfield 8 (1960). It's worth talking about the New York Times *film critic Bosley Crowther for just a moment here. He was powerful, and he had absolutely savaged* Suddenly, Last Summer. *When the always thin-skinned Gore Vidal, who had served as screenwriter along with Tennessee Williams, alleged that Crowther's attack on themes of homosexuality, incest and rape had actually helped the box office, Crowther was painted as a bluenose. But he was painted incorrectly; those were not his quarrels with* Suddenly, Last Summer. *(If you read the original review online, you will see that he had other quarrels.) And when* BUtterfield 8 *opened in November of 1960, Crowther knew exactly what Elizabeth Taylor had to offer, and so did the audience, and so did the Academy. On Oscar night in 1961,* LIFE *had more than one shooter in deployment covering the ceremony. The sequence above, in which Liz experiences or feigns shock and then is congratulated by husband Eddie Fisher, was made by the accomplished Ralph Crane. The after-party shot of Liz and her prize (right) was taken by the equally estimable Allan Grant.*

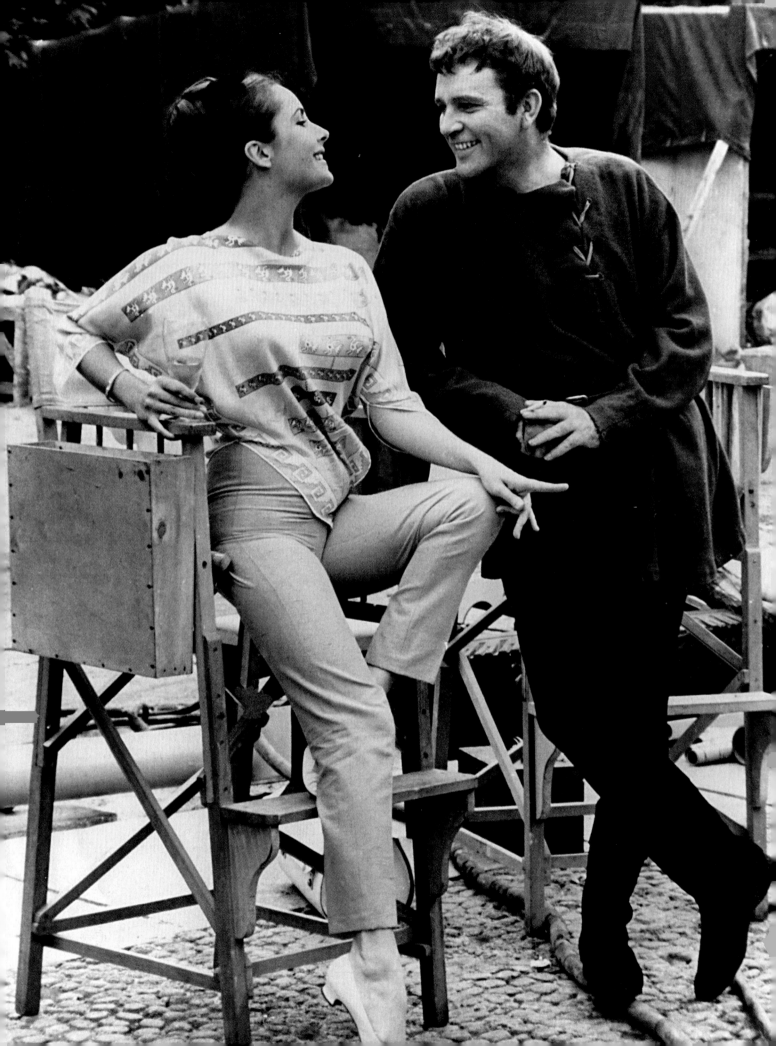

Liz and Dick
1963–1976

TIME MAGAZINE ONCE ASKED THE GOSSIP COLUMNIST LIZ SMITH TO MEAsure the romance of Elizabeth Taylor and Richard Burton against those of other famous, in-the-limelight couples—the Duke and Duchess of Windsor, Charles and Anne Lindbergh, Gertrude Stein and Alice B. Toklas, Spencer Tracy and Katharine Hepburn. Smith pointed out that Liz and Dick made their conjoined fame and notoriety simply on the basis of their relationship and the magnitude of their personalities—no murders, abdications or other accessory tidbits attached or required. Theirs, said Smith, was "the most vivid example of a public love affair that I can think of. The Burtons and the Lindbergh baby being kidnapped and Kennedy's assassination—these were the biggest stories of our time. Whenever somebody says, 'So and so is a big star,' I say, 'Have they been condemned by the Vatican?'"

Liz and Dick indeed were recognized by the Church—if not specifically and eternally damned to the fires of hell, at least denounced for their well-publicized and initially adulterous carryings-on, their "erotic vagrancy." One can opine here or there on the morality of their behavior, but it must be admitted: That's star power. You're hot stuff indeed when the pope is paying attention.

The whole thing is now known as Liz-and-Dick, but in its day, particularly at the beginning, it was Liz and This Shakespearean Guy from England (or Someplace). The someplace, as it happened, was Wales. In America certainly and also in the much larger global nation that is Showbiz, Elizabeth Taylor was the star and Richard Burton was the latest supporting actor to be suspected of trying to glom on to her stardom. This perception certainly bothered Burton, who was a man of immense talent and many insecurities. But nothing, including this imbalance in their fame, could get in the way of their passion. Nothing . . . including their spouses.

They were both married when they first espied one another, which we should note for purposes of historical accuracy was not on the set of *Cleopatra* but at a hotel swimming pool in L.A. in 1952, when Burton, "the next Olivier" in the same way that Springsteen would be, for a moment, "the next Dylan," had arrived in Hollywood. Burton, for his part, later remembered being awed by Taylor's almost absurd beauty. He nearly laughed out loud, so gorgeous was this particular creature among the many lovely poolside creatures he was apprehending. "She was lavish," Burton wrote in his diary. Her breasts were "apocalyptic, they would topple empires before they withered . . . her body was a miracle of construction . . . She was a dark unyielding largesse. She was, in short, too bloody much, and not only that, she was totally ignoring me." Which was initially a good thing. Burton was, at the time, married

Just friends? Perhaps for the moment. The stars of Cleopatra *share a smile during a break in filming in 1961. Well offstage, Sybil Burton and Eddie Fisher start to hear rumors.*

to Sybil, as he had been since 1949 and would be a decade later when, for better and worse, his attraction to Taylor, and hers to him, became impossible to deny. Taylor was, in 1952, married to Michael Wilding. In 1962, when she and Burton were brought together again—yes, this time on the set of *Cleopatra*—she was married to Eddie Fisher. But no matter.

The hoary term "hot and heavy" does not begin to describe the early days of the Liz and Dick relationship. This is why the Vatican felt compelled to enter the fray: Everything was so (to borrow Burton's adjective) bloody obvious—so flagrantly on display—that everyone in the wide, wide world had an opinion. How uncontrollable was their love and lust? The director of the film would order "Cut! And print it!" at the end of smooching scenes, but although Antony and Cleopatra might have finished their kiss, Liz and Dick most certainly had not. "Would you two mind if I say, 'Cut'?" the director would ask again. "Does it interest you that it is time for lunch?"

They hired villas here and there, they spent holidays together. Eddie Fisher back in Los Angeles was told by the gossip columnists what was up, and eventually, grudgingly—very grudgingly—he accepted reality. Sybil, who had grown somewhat used to her husband's multiple infidelities, came to terms with the fact that this one was different.

The scandal—it was Burton who coined the tabloid term *le scandale* to describe media storms like the one he and Liz fomented—made the Welshman an object of great fame and envy, an object nearly the equal of Taylor. By April of 1963, *Time* was reporting: "Everyone, in short, knows who Richard Burton is, or at least what he is at the moment. He is the demi-Atlas of this earth, the arm and burgonet of men, the fellow who is living with Elizabeth Taylor." Quite as soon as preexisting marital entanglements were dissolved, he was the fellow who was wed to Elizabeth Taylor—on March 15, 1964, in Montreal, at the Ritz-Carlton Hotel, a Unitarian minister presiding. Elizabeth's hair was braided with white Roman hyacinths, and she wore a yellow chiffon gown designed by Irene Sharaff, who had made the costumes for *Cleopatra*. The Burtons checked out of the Ritz as husband and

wife. If the Vatican breathed any sign of relief, it went unheard beyond the Holy Door of St. Peter's Basilica. Elizabeth's characteristically wry observation much later about the whole shebang: "I don't remember much about *Cleopatra*. There were a lot of other things going on." Now *that's* a movie star.

The backstage, backdoor Burtons now became the boozy, battling Burtons. Their fights were legendary, but according to Liz, talking with Larry King in 2006, any bitterness never lingered: "Well, we got it all out on the set and we'd go home, have dinner with the children, play word games with them, and learn our lines after dinner . . . and go to sleep . . . It was very cathartic, too, because we would get all our shouting and balling out on the set and go home and cuddle." The boozy, battling, cuddly Burtons.

Taylor's testimony on *Larry King Live* reminds us of a fact that went entirely missing when this magnetic couple was the story of the hour: There were children. In fact, lots of them. At the end of her life, Elizabeth Taylor, whose devotees were many, still called her kids her "best friends." Elizabeth brought to the union her two sons with Michael Wilding and her daughter with Mike Todd. Richard's daughter (with Sybil) Kate, who today is an accomplished actress, began spending more and more time with her father. A sad note is that Kate's younger sister, Jessica, suffered from a mental illness that caused the Burtons to decide she should be institutionalized, and after Richard married Elizabeth, he saw his youngest daughter rarely. And finally there was Maria, who was born in Germany in 1961 and adopted by Liz and Dick in 1964. It's extraordinarily hard to think of the Burtons as a nuclear family, but there you have it: the bunch of them, sitting around playing word games.

At the office, which was of course the movie set, Mom and Dad were diligent and successful—for a time. They would eventually make 11 movies together, including some good ones and one truly great one, *Who's Afraid of Virginia Woolf?*, directed by Mike Nichols in 1966. Way back in 1949, the precocious Liz had told *Time* magazine, "What I'd really like to play is a monster—a hellion." It seemed absurd at the time, young Elizabeth being so sweet and pretty, but now the child's dream came true as she purposely gained

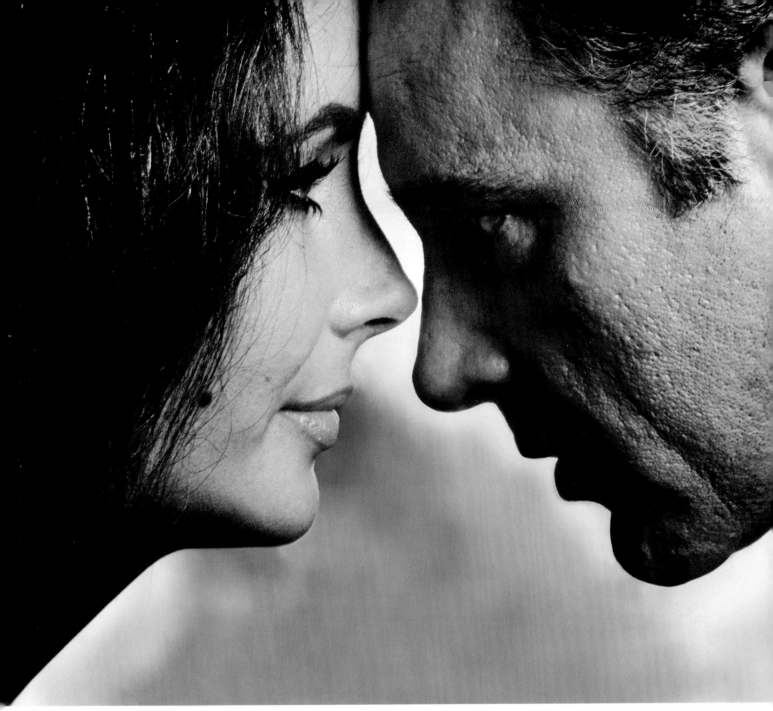

If there are two words in the English language that most apply to Liz and Dick, they are passion *and* intensity—
and this portrait made in 1965 in the City of Lights, Paris, captures both.

weight and played drunk and slovenly as Martha, half of a brutal marriage with Burton's George. Of course, parallels were drawn to real life by all who saw the movie, but the performances were as sensational as the scuttlebutt, and both Burtons were nominated for Academy Awards. Elizabeth won her second and Richard lost again.

When John Wayne as Rooster Cogburn in *True Grit* beat out Richard's Henry VIII in *Anne of the Thousand Days* in the spring of 1970, the Welshman had gone zero-for-six and, at least in the opinion of columnist Liz Smith, his professional problems (neither his nor Elizabeth's movies were money-spinners anymore) had become such that, for the two of them, this was "the final blow. They worked the circuit, they attended the Golden Globes luncheon. Elizabeth has her new big ring. They did everything possible to campaign to get him that award. They attended the Oscars. She agreed to be a presenter for Best Picture. Edith Head dresses her. But what happens? John Wayne is the winner. And she has to go up after that and give the Best Picture award to *Midnight Cowboy*. You could just see that not only was she furious, God knows what waited for her back in the hotel."

There's no question but that Burton was hurt by Hollywood's slight, and he was distressed by his and his wife's sagging box-office clout, but there were other, even more important matters that might have precipitated his increasing despondency. In 1968, he and, among others, his elder brother Ifor Jenkins (Jenkins being the name Burton was born with) had engaged in too much elbow-bending at Burton's getaway home in Céligny, Switzerland. Ifor had slipped and broken his neck, leaving him paralyzed. He died in 1972, and Richard's younger brother, Graham Jenkins, speculated that this spurred Richard's own beyond-the-pale drinking. Also, in February 1975, Richard said in an interview with David Levine that he had "tried" homosexuality, and that, maybe, all actors were latent homosexuals, and "we cover it up with drink." Whatever the causes, Burton's problems with alcohol were, in the late 1960s and '70s, thoroughly out of control. Liz, too, liked the bottle, claiming she had "a hollow leg" but later checking into the Betty Ford clinic twice for drug and alcohol dependency. When it came to dissolution in this period, however, she was no match for her husband.

Push had to eventually arrive at shove; a breaking point eventually had to be reached in a relationship as volatile and pressure packed as this one. On June 26, 1974, this most famous of couples divorced in Saarinen, Switzerland. Very soon thereafter, each had another amour on his or her arm. But lo and behold, they re-wed on October 10, 1975, at the Chobe National Park in Kasane, Botswana, this hastily arranged service officiated by an African district commissioner of the Tswana tribe. Richard later recalled the craziness that informed their mutual obsession in a biography by Michael Munn: "I just suddenly found myself with Elizabeth again. What the devil was I thinking of? She wanted to get married again. I didn't. But I married her again all the same. What Liz wants, she gets . . . I found her irresistible, and in the end I found myself on one knee—literally—proposing to her. I'd actually stopped drinking by then, so I should have been sober enough to know

what I was doing, but I didn't. So after she accepted, I got drunk . . . I knew it was over before it had begun."

If not precisely that soon, almost: They divorced a second time nine months later on July 29, 1976.

Burton continued to drink, and finally enlisted a doctor's help in conquering his affliction, but to no avail until he married Sally Hay in 1983, at which point, it seems, it was too late.

He and Taylor were never out of one another's lives, even as they went on to other spouses. They actually reunited, professionally, in 1982, for a stage tour of Noël Coward's *Private Lives*. An ad in *The New York Times* showed a big heart emblazoned with the words "Together Again!"—an arrow piercing it. This was no artistic triumph ("They have become one word: Liz'n'Dick," said *The Christian Science Monitor*, "[c]ondemned to be Antony and Cleopatra in an endless sequel of daily life."), but it played to sold-out houses.

Burton appeared frail during the run of the play, and he died of a cerebral hemorrhage two years later at age 58.

Taylor always said she continued to love him and speculated that they might have, in fact, found a way to marry yet again. Late in her life she made conscious efforts to keep Burton's flame alive, even unto sharing their love letters with the writers Sam Kashner and Nancy Schoenberger. This led to the terrific 2010 book *Furious Love: Elizabeth Taylor, Richard Burton and the Marriage of the Century*—perhaps the best beach book ever written. It ends, fittingly, with a story about the last letter Elizabeth received from the man who was unquestionably the love of her life: "Richard had mailed it on August 2, 1984, so it arrived a few days after his death. It was waiting for Elizabeth when she returned from London, after attending Richard's memorial service there. It was his final letter to her, the one he had slipped away to write in his study at Céligny, surrounded by his books. It was a love letter to Elizabeth, and in it he told her what he wanted. Home was where Elizabeth was, and he wanted to come home."

She kept that letter by her bedside ever after.

By 1971, Liz and Dick's blockbuster days are past, but they are still news. Among their cinematic offerings filmed that year: an adaptation of Welshman Dylan Thomas's Under Milk Wood, *in which Dick plays a drunken gadabout.*

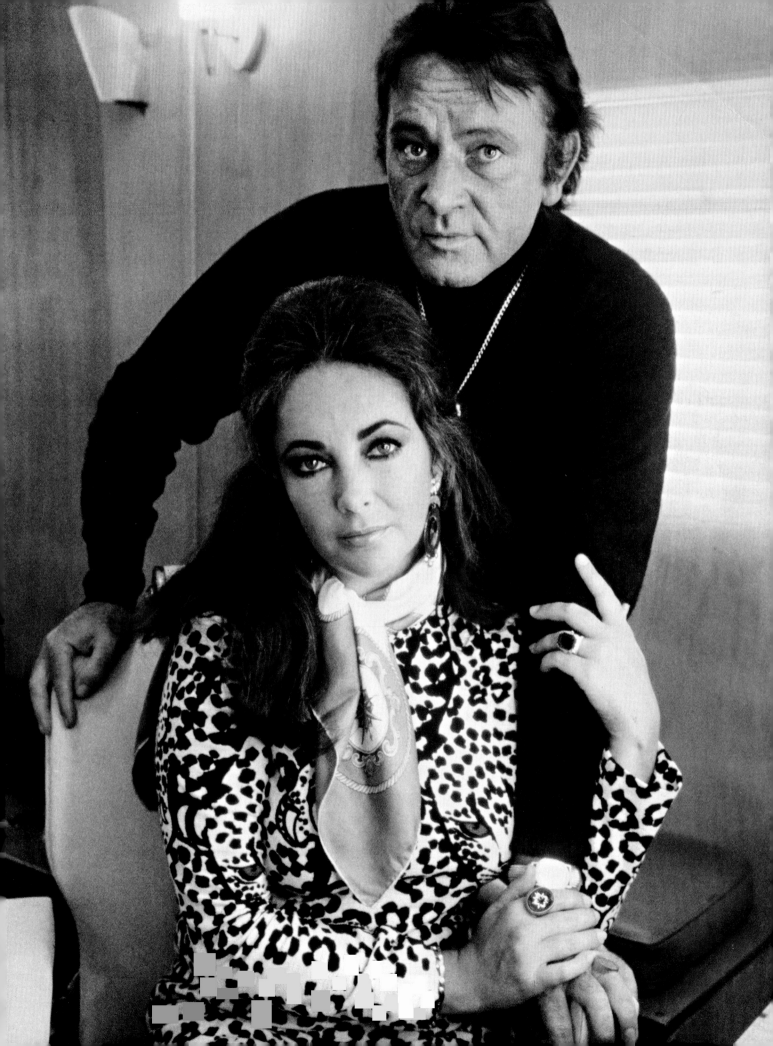

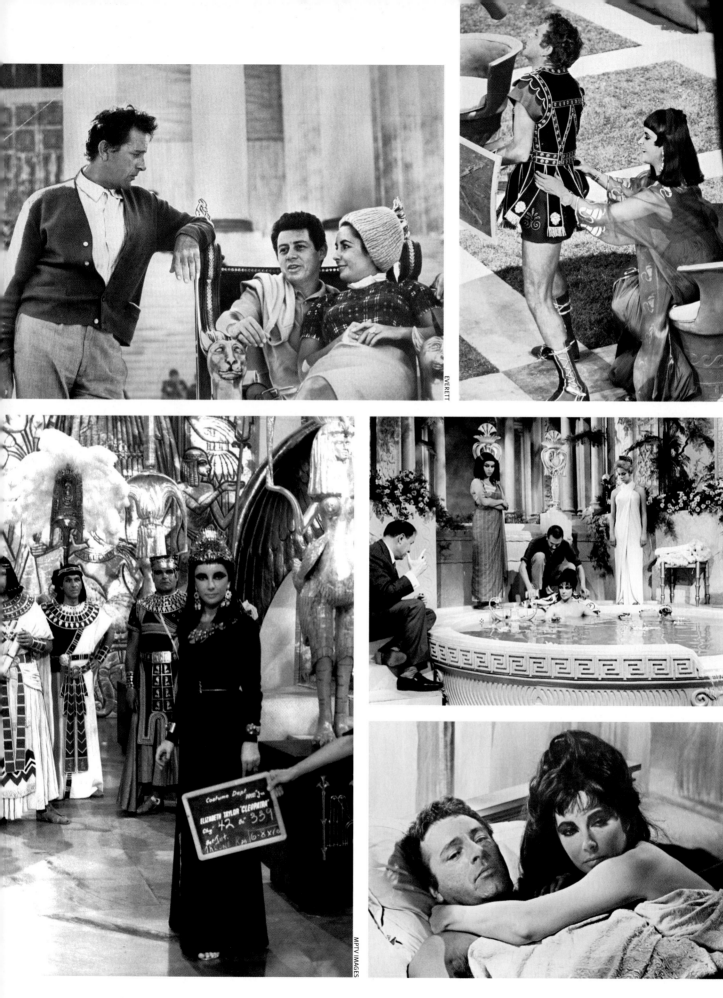

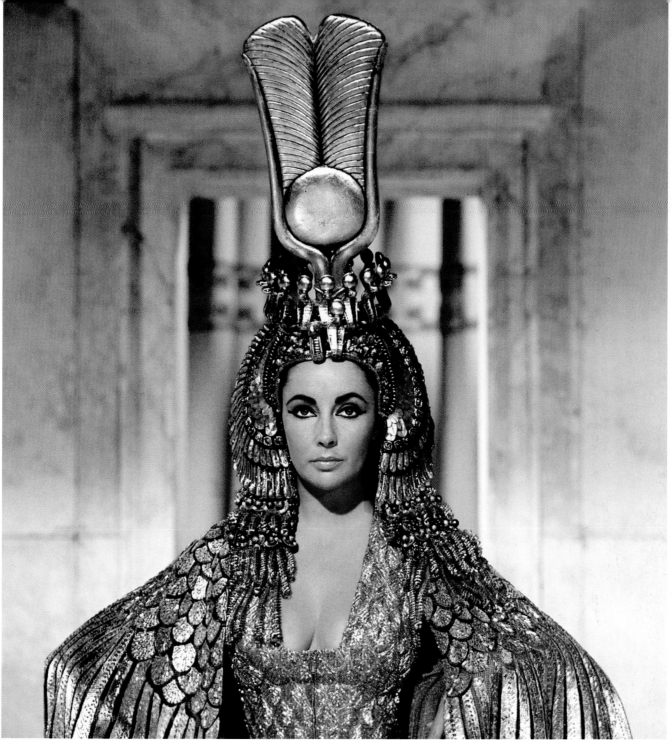

The positively incredible thing about the movie Cleopatra is that its sensational source material—Antony, Caesar, asps and all—seems minor league compared with the intrigues of an early 1960s film set. The production got off to a wheel-spinning (and money-spinning) start: Does the script stink? Is Liz too overweight for the role? Is she drugged up? Who's Richard Burton? Is he a drunk? Is she really making a million bucks plus a percentage? How're you gonna replicate the hot Roman sun on a dreary London film set? Aren't those two married to other people? What the heck's going on? Where's Eddie? Well, the answer to the last question was: most often in L.A., worried silly. But in the photo opposite, top left, he is visiting the set and snuggling with his wife while chatting amiably with Dick. Elsewhere on the page we see Elizabeth playfully—playfully? meaningfully?—making a grab at the barely tunicked behind of her new beau, and both stars accepting direction from Joseph L. Mankiewicz, who had guided Liz masterfully in Suddenly, Last Summer. Liz and Dick would accept direction on the set, but not off, as their weekend assignations became ever more indiscreet. It should not be believed that either Sybil, who had already weathered many a marital storm, or Eddie took this well. In recent years it has been learned that Eddie at one point confronted Elizabeth in their bedroom with a gun, though he ultimately avowed that he wouldn't—couldn't—shoot her because she was so beautiful. You can't make this stuff up, nor can you overemphasize how over-the-top Cleopatra was—both in the making and once it was completed. But LIFE's Howell Conant came pretty close to capturing just that—the whole production's outsize outrageousness—in the color photograph above.

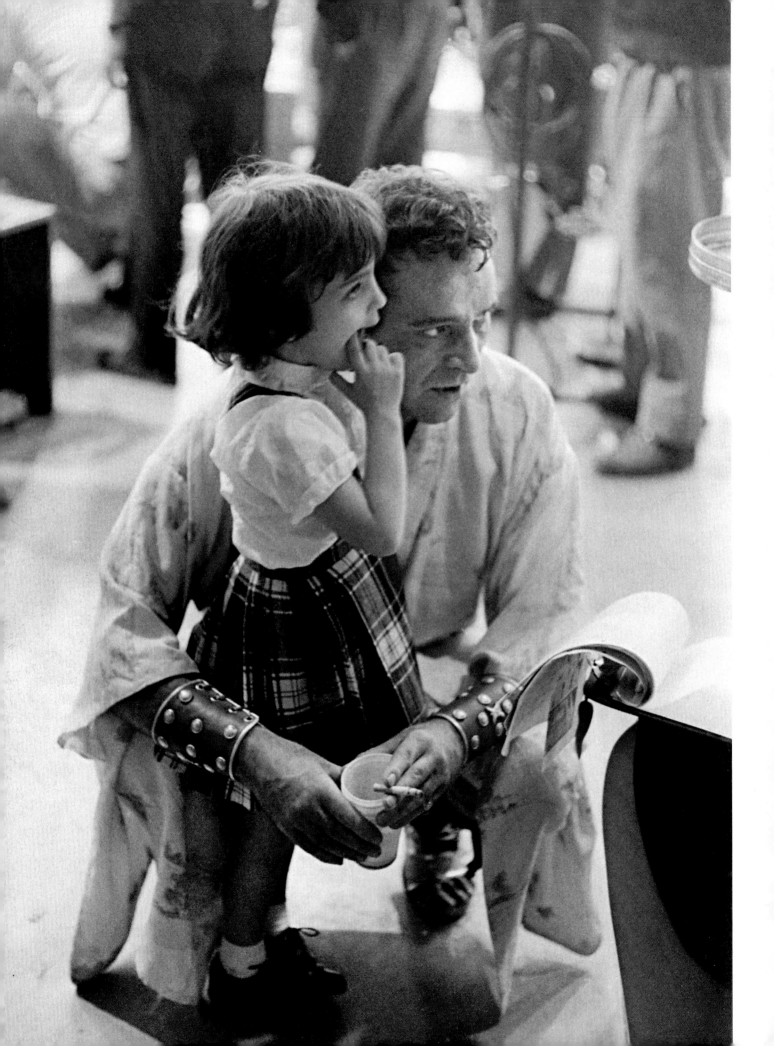

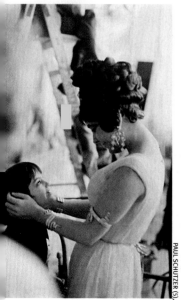

A word here about Paul Schutzer, who took all of the pictures on these two pages: He was one of LIFE's best-ever shooters. That he was brave is evident: He got up close and personal with the Burtons, who, actually, behind the scenes were very warm, loving people (the girl in these pictures from 1962 is Liza Todd, who was adopted by Dick once he married Liz; they also adopted a daughter of their own, Maria, in 1964; the boys are Liz's by Michael Wilding). So Schutzer was brave on the Hollywood beat, but he was braver still, and he possessed a poet's soul. As a youngster, he considered becoming a painter or lawyer, following his father and brothers, but at 22 yielded to his childhood love of photography. He was only 26 when he joined the LIFE staff. He had a knack for taking pictures of powerful people— Eisenhower, Nixon, Kennedy . . . and Taylor, and Burton—yet he said, "It's the quiet things that happen around us every day that are the really important things. A good camera story need not be dramatic, but it must be entertaining and a personal adventure for the viewer." That's certainly so, and the pictures on these pages prove it. But Schutzer never shied from dangerous subjects; in fact, one colleague said he had "almost too much courage." Schutzer was killed at age 36 on the first day of the Six-Day War between Israel and (oddly enough, considering Cleopatra) Egypt in 1967 when the Israeli half-track in which he was riding was struck by a 57mm shell. We mention all of this only by way of explaining the LIFE photographers who documented Liz for us— and thus for the American public—through the years. Stackpole, Landry, Schutzer: They could do it all, as was their mandate. They were war photographers one day, then covering the Battling Burtons the next, making tough and tender pictures on every assignment. There was never a team like that one, and never will there be such a team again.

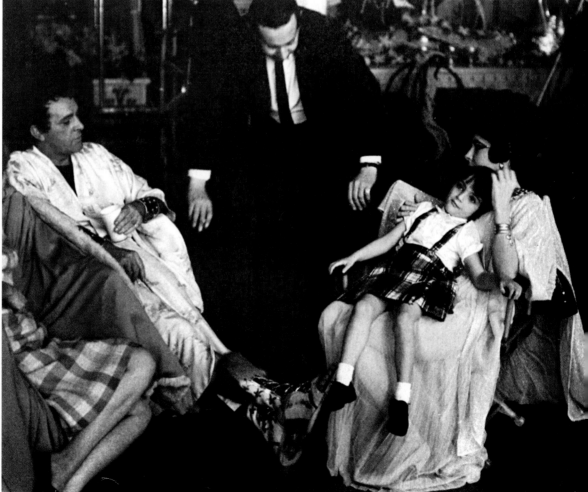

PAUL SCHUTZER (5).

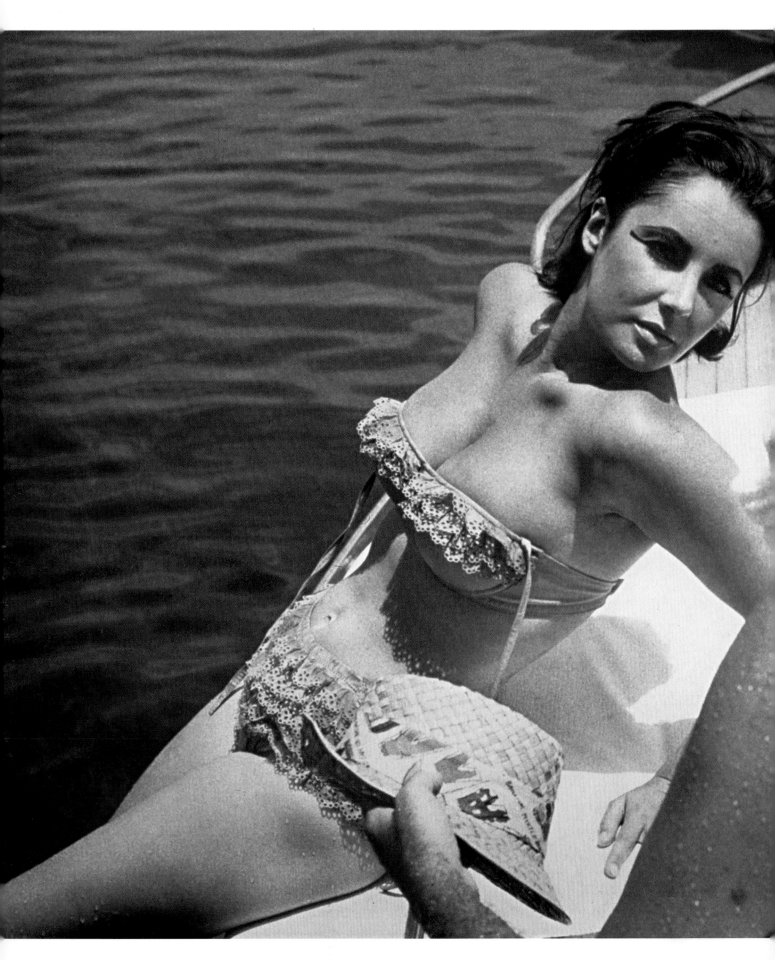

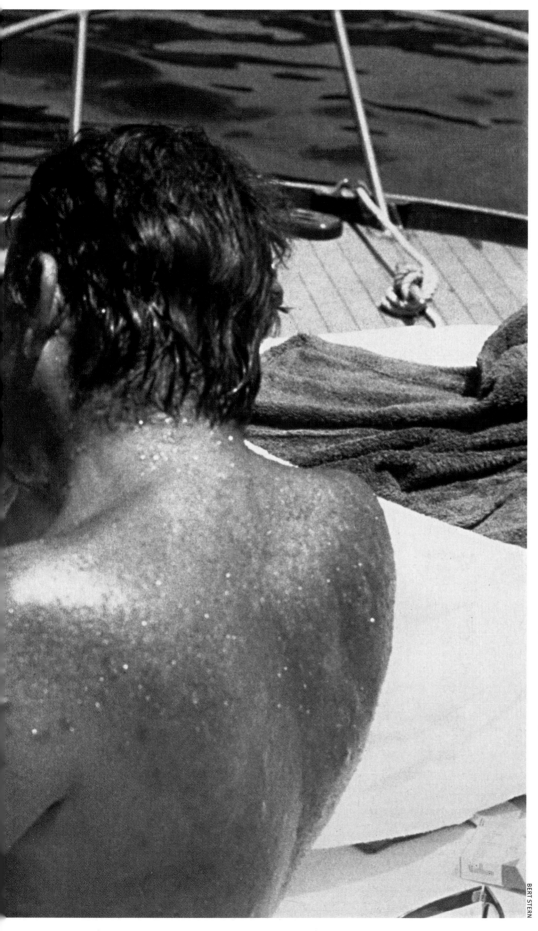

ert Stern was not a LIFE
photographer, but he was
a terrific photographer,
and he could make a sexy picture
with the best of them. His Marilyn
Monroe photographs are iconic
and justly praised for their artistry,
but we would aver that none
of them trumps this shot of Liz
and Dick just, ummm, chatting
while out for a casual, uhhh, boat
ride in 1962. She is, by now, a
thoroughly dangerous woman in
the eyes of her multitudinous and
happily addicted fans. She is a
Hollywood home-wrecker and a
titan of the tabloids. In the early
and then mid-'60s, the Cold
War is happening, the Beatles are
happening, Dylan is happening,
James Bond is happening,
Andy Warhol is happening and the
times they are a-changin', but for
adult film fans, there is Liz and
Dick. Taylor is at this point, as
Camille Paglia, the pop sociologist
college professor, wrote in the
All-Liz 75th birthday edition of
Warhol's Interview magazine,
"the archetypal femme fatale, the
sexual predator, the adventurous,
smoldering brunette vixen . . .
the flaming embodiment of the
erotic energies of the universe!"
Holy apocalyptic breasts, Batman!
(Just by the way, Batman was
huge about that time, too, in the
camp TV version.) If Paglia's
prose is, in fine Liz fashion, quite
a bit too much, you nonetheless
get the point: The girl who once
made nice with Mickey, Roddy,
the collie and that horse has grown
into a woman whose glamour and
purposeful glance shout: Danger!
More dangerous still: She likes it
this way.

BERT STERN

65

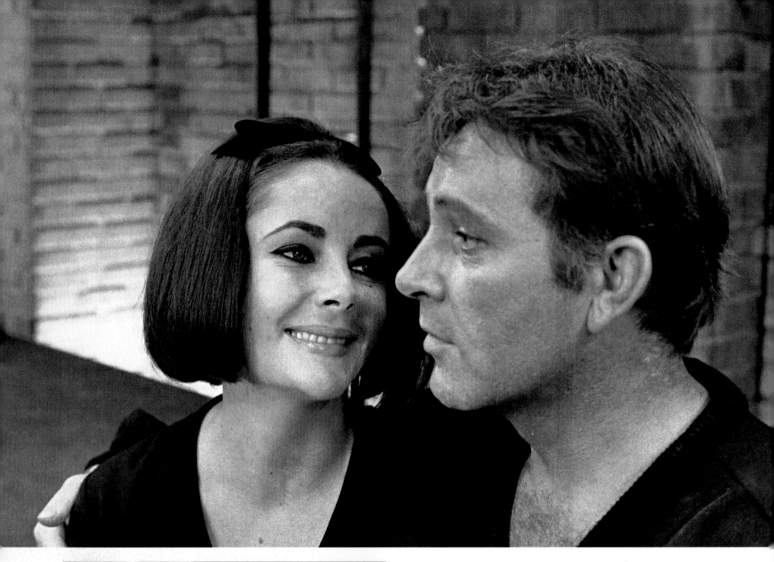

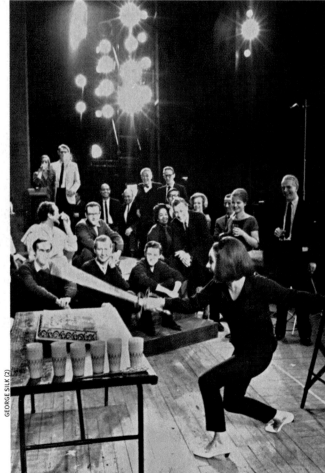

A true star of that storied LIFE team that we describe in the caption on page 63 was George Silk, a New Zealander born in 1916 who joined the Australian Army as a photographer in World War II and was captured by Rommel's troops in North Africa, eventually escaping and finishing the war as a LIFE shooter in the Pacific. He said at one point he felt ashamed not to be fighting himself, "so I drove myself to show the folks at home, as best I could, how the soldiers lived and died." After the war, he was happy to go on to other subject matter, particularly sports, in which realm he became a pioneering artist in the pages of LIFE and Sports Illustrated. He made the lovely portrait of Elizabeth, above, smiling at Richard backstage while he is starring in the Broadway run of Hamlet in 1964, and of Liz using a prop sword (left) to cut her birthday cake when Dick throws her a party at the theater. On the opposite page are photographs from the set of The Night of the Iguana, starring Ava Gardner and Richard, which was filmed largely in Puerto Vallarta, Mexico, in 1963. Liz visits the production, as we see (there's no way she was letting Dick hang out in hothouse Mexico with Ava Gardner sans chaperone). Also visiting is the LIFE photographer Gjon Mili—for once not a veteran of the war, but a technical and lighting wizard perhaps best remembered for his jazz-scene pictures and a definitive portrait of Pablo Picasso sketching with a penlight.

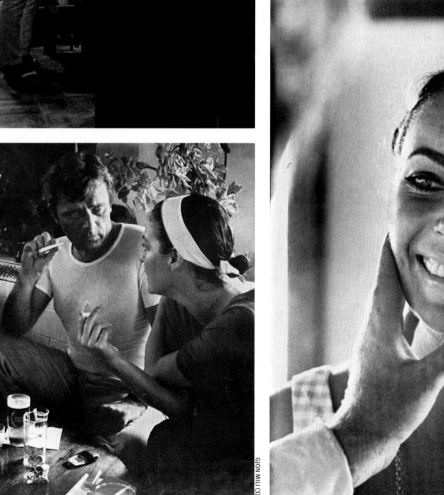

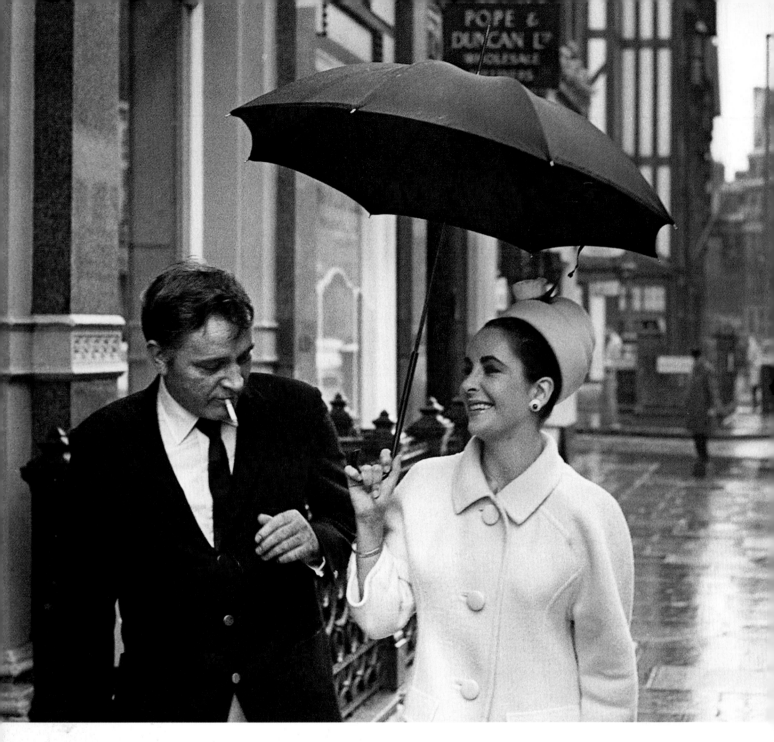

Tying the knot, Take One: In December of 1963, after 14 years of marriage, Richard divorces Sybil Williams—the mother of his two daughters—whom he had met on the set of his first movie in 1948. Three months later, on March 6, 1964, Elizabeth divorces Eddie Fisher after what was, by comparison, a marital fling. Above: The flagrant paramours seem happy even in inclement weather in '63, but in fact the prenuptial period was hell for Burton. Liz was used to this kind of thing, but Dick was answering Sybil's demands with a settlement of a million dollars and, far more witheringly, embarking on a months-long period—a "nightmare" time—in which he would not see his two children, Kate and Jessica (and would rarely see the severely autistic Jessica ever again). This was a whirlwind, pressure-filled time not only socially but professionally for Burton. He was in talks with John Gielgud, who was to direct him in an upcoming production of Hamlet on Broadway; his movie Becket was about to make him a star on the level of Taylor; he was about to fly down to Mexico for a production costarring Ava Gardner and Sue Lyon. Buckling, he suffered what has been diagnosed from afar as a nervous breakdown, which Elizabeth nursed him through. He started drinking even more heavily than usual. Yet he does appear healthy, happy and resolute in Montreal on his first wedding day with Elizabeth: March 15, 1964 (opposite). The ceremony at the Ritz certainly seemed in character with the frantic moment—only about a week having passed since Liz's divorce; Dick's secretary Jim Benton serving as best man—but some, including photographer Henry Grossman, whose later work for LIFE with the Beatles would become legendary, had obviously been alerted. Nothing in the saga of Liz and Dick, and surely nothing this significant, would be allowed to ensue without pictures.

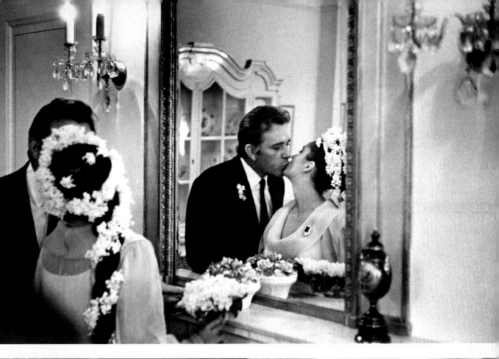

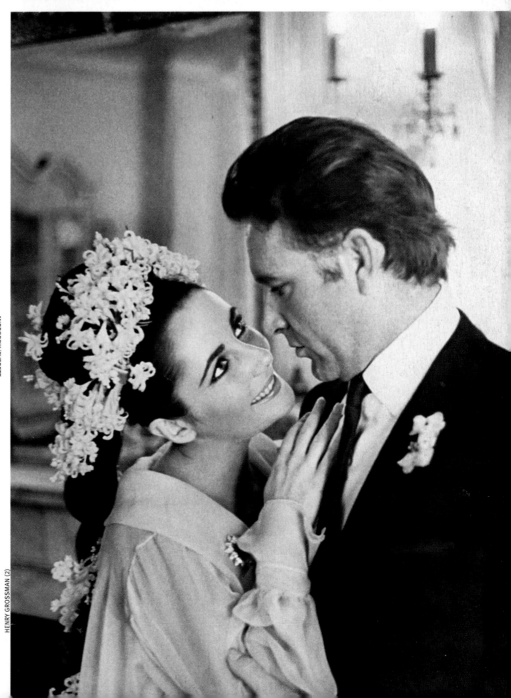

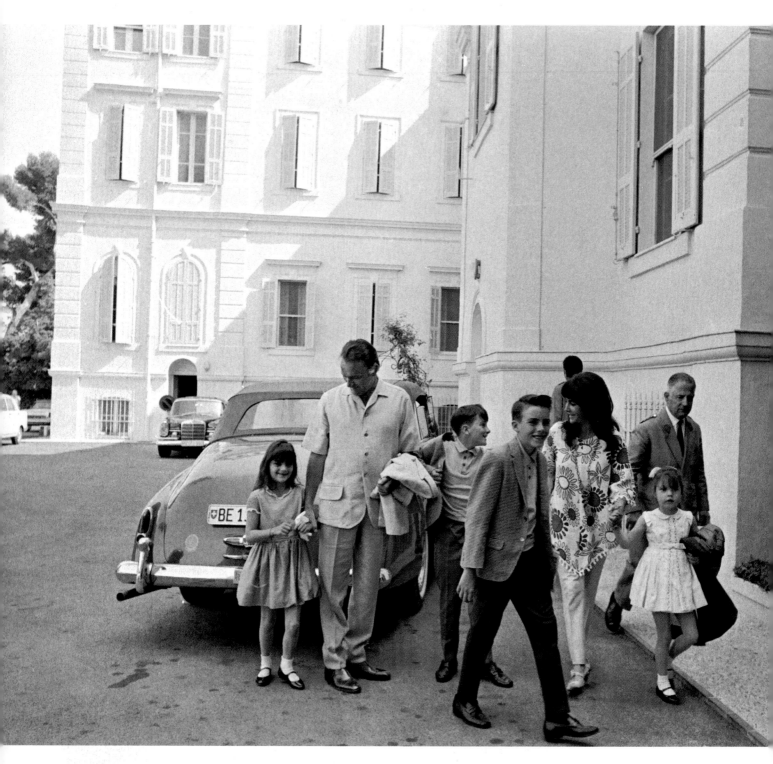

The world saw them as Liz-and-Dick. They saw themselves as a family, just at the time when the societal concept of "a nuclear family" was taking hold. Their children routinely included her three by Michael Wilding and Mike Todd, their adopted daughter, Maria, and, increasingly, Richard's daughter Kate, who would become an acclaimed stage actress. Above: Richard shepherds the brood in 1965. On the opposite page are three photographs taken that same year by Bob Willoughby. From the top, we have, from left, Michael Wilding Jr., Liza Todd, Kate Burton and Chris Wilding with their parents; a fishing expedition; and then Liza, Mom, Michael, Dad, Chris and Kate. With the children

around, the Burtons' home life did approach the idyll pictured here—various recreations, reading, board games and the like. This was true. Also true: When left to their own devices, Liz and Dick were Liz-and-Dick, and the "Battling Burtons" legend and fact led to them being cast, this year, over Bette Davis and James Mason as the boozy, brawling protagonists in the film version of Edward Albee's searing play Who's Afraid of Virginia Woolf? Albee himself had been excited at the prospect of Davis and Mason and was surprised by the arrival of Taylor and Burton, but at the end of the day he agreed that they were right for the roles. When it came to research and rehearsal, they had diligently done their homework.

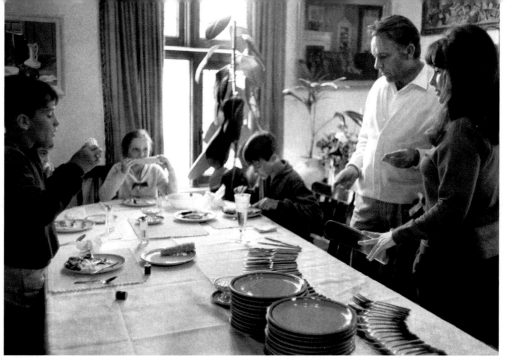

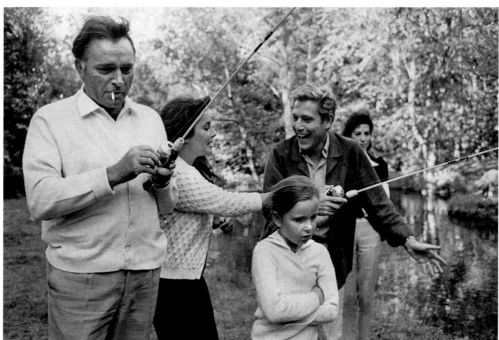

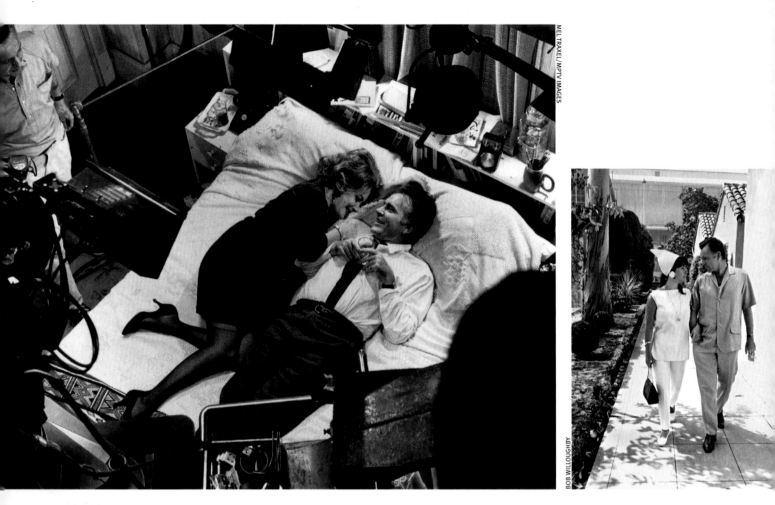

Some movies get good reviews, some movies are destined to be classics, some movies make news. In 1966, Who's Afraid of Virginia Woolf? was one of those rarities, like Citizen Kane, Midnight Cowboy and perhaps (too soon to tell) The Social Network, that did it all. Liz, still one of the world's most beautiful women, gained 30 pounds to bring to life the blowsy Martha, while Dick channeled his insecure nature (not to mention his inner and outer drunk) to incarnate George (above). After work, Liz would doff her wig, wash off her age makeup and return to the woman the world knew well—as the Bob Willoughby photo above at right proves. Ever since Albee's play had opened on Broadway in 1962, it had been considered unfilmable due to its coarse language and tough themes. As soon as director Mike Nichols (opposite page, top left), who would also make the 1967 game-changer The Graduate, began filming, the Catholic Legion of Decency threatened to slap the end product with its dreaded CONDEMNED rating. When Warner Bros. execs viewed a rough cut of Nichols's work, with a LIFE reporter also watching and taking notes, one of the honchos exclaimed, "My God! We've got a seven-million-dollar dirty movie on our hands!" What they had on their hands was a masterwork, true to Albee and elevated by the brilliant work of Nichols, Taylor, Burton, and supporting actors George Segal and Sandy Dennis—a film so artistically accomplished that even the Catholic ratings board backed down. Not everything the Burtons touched in this period turned to gold, however. Just below the photograph of Nichols and Taylor is a shot of Burton and Taylor rehearsing for an Oxford University Dramatic Society production of Doctor Faustus, which Burton would then codirect as a 1967 film, proving mainly that this couple could do whatever they pleased. "By the time Richard Burton was in a position to star in a movie of Marlowe's Doctor Faustus, further dealing with the Devil probably had become anticlimactic," wrote the famed critic Pauline Kael. "This production, with Elizabeth Taylor as Helen of Troy, is the dullest episode in the Burton and Taylor great-lovers-of-history series that started with Cleopatra. Eventually, Burton gets to the speech that begins, 'Was this the face that launched a thousand ships' and ends 'And none but thou shalt be my paramour!' By then it's clear that Faustus and Helen are just Dick and Liz." Another approximate bomb was Boom!, a $5 million 1968 adaptation of Tennessee Williams's play The Milk Train Doesn't Stop Here Anymore. Vincent Canby of The New York Times, reflecting the view of the masses, wasn't keen on the movie or Taylor's performance, but found Burton "earnest and mellifluous" and wrote that "the one unequivocal success is a brief appearance by Noël Coward" (opposite, bottom, on the set with Liz and Dick). Years later, as we will see in the coming pages, the at last unalterably divorced Burtons would reunite for a stage tour in Coward's classic comedy Private Lives. The final photo on the opposite page shows Liz dancing with ballet legend Rudolph Nureyev at London's Dorchester hotel in 1968. She never slept with him or married him, but we include the picture because, well, it shows Elizabeth Taylor dancing with Rudolph Nureyev. On the pages immediately following: Another sexy portrait by Bert Stern of history's sexiest-ever couple.

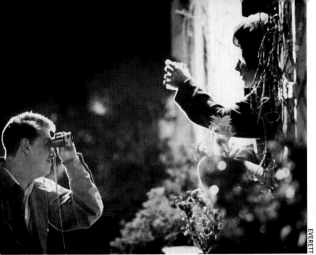

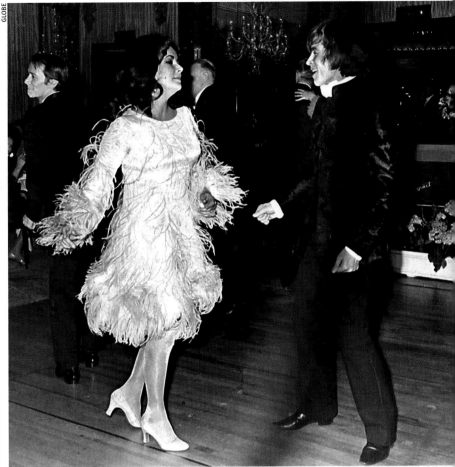

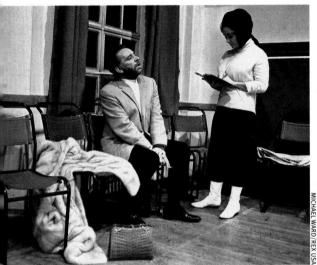

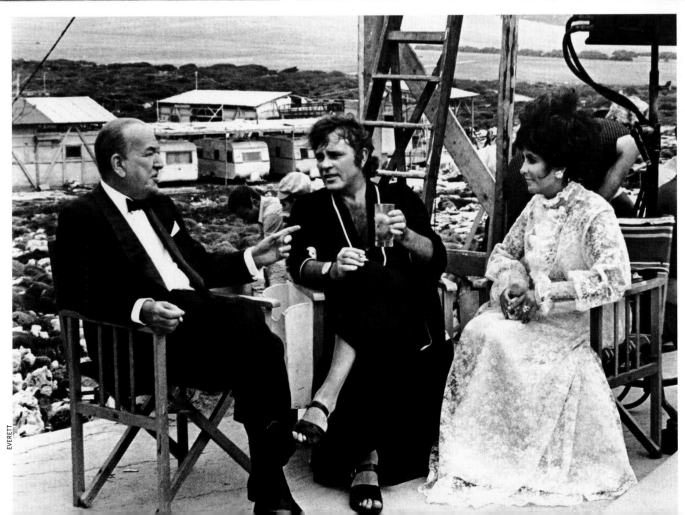

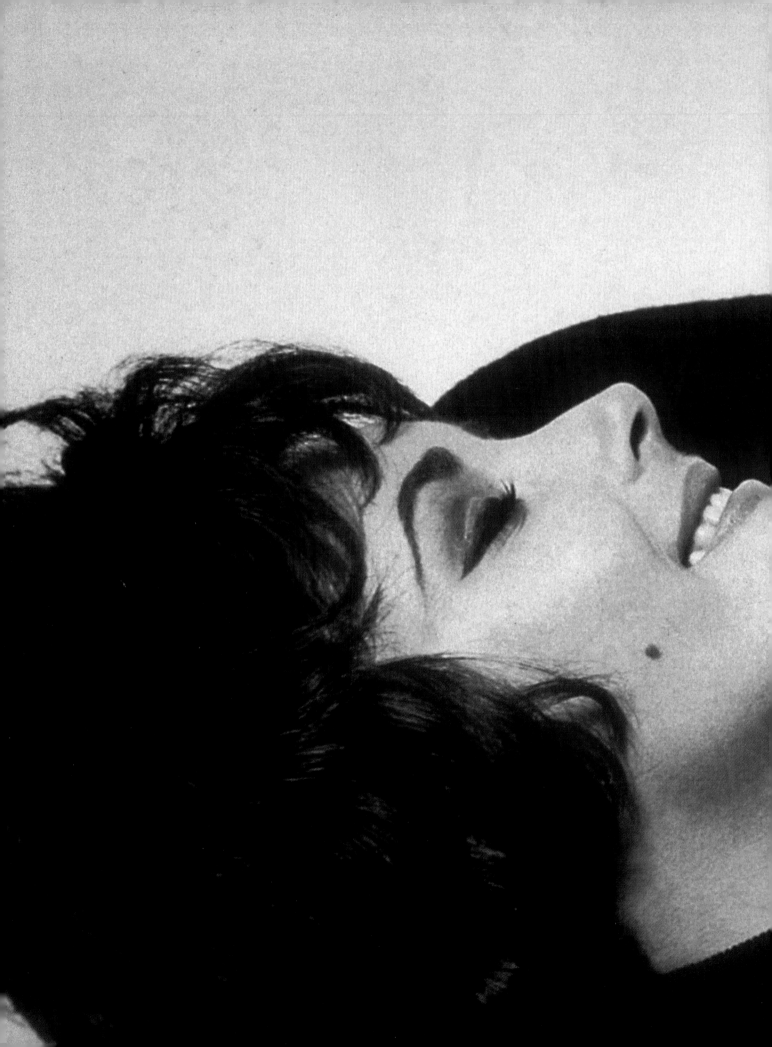

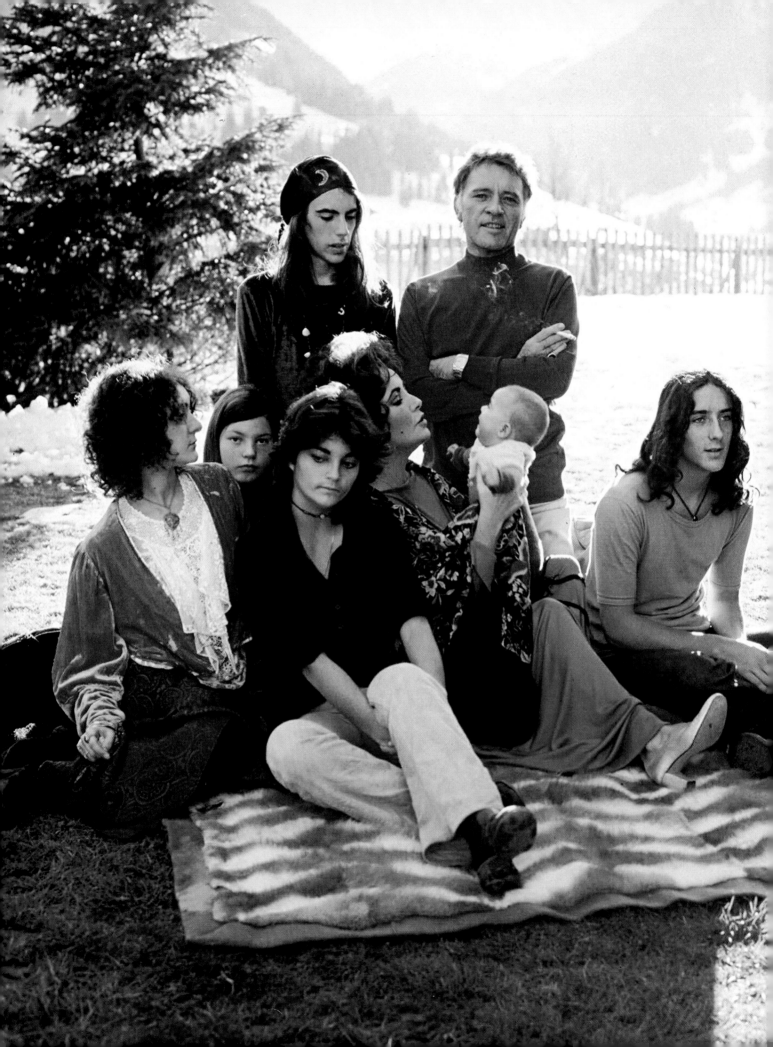

Tying the knot, Take Two: After they divorce in 1974 (a split that lasts not quite a year and a half), they remarry in October '75 (above). This second try will be ill-fated—they would separate within four months, call it quits for good in July of 1976 and each be married to someone else by year's end—but the point is that they do try. "I love Richard Burton with every fiber of my soul," Elizabeth once said, "but we can't be together." Indeed. Never before and never since has the idea of volcanic, impossible love been so acutely rendered in real life, real time, before our very eyes. When Elizabeth and Richard first came together, the entire world knew it was absolutely perfect and also a terrible mistake. They probably knew it too. And yet for nearly a decade and a half—an epochal time frame in the life of Liz Taylor, when you think about it—they made it work (and didn't), made great art (and didn't), made constant headlines and raised a family (left) of which they were justly proud. You have to go to fiction—Romeo and Juliet, Heathcliff and Catherine—to find anything approaching Liz and Dick. Tracy and Hepburn, Gable and Lombard, Bogie and Bacall, Charles and Di, Gwyneth and the guy from Coldplay: These are relationships in an entirely other and lesser league. So are, for that matter, Liz and Nicky, Liz and Eddie, Liz and Larry, Liz and . . . Just reading those names in sequence speaks to the absurdity of any such comparisons. Liz and Dick. There will never be another like Liz and Dick.

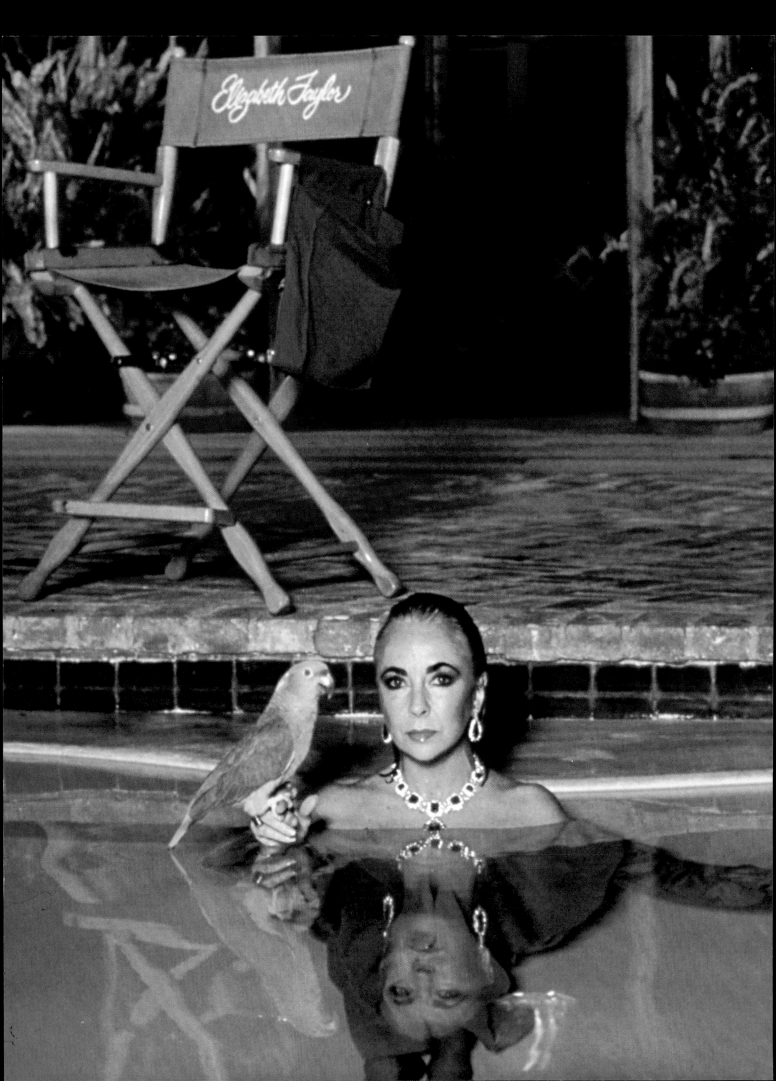

New Courses, New Causes

AMONG THE MANY THINGS THAT ELIZABETH TAYLOR UNDERSTOOD well: Life goes on. Academy Awards . . . marriages . . . movies that bomb . . . multiple surgeries . . . congestive heart failure—well, life goes on. Richard Burton? Life goes on.

And it did. It would have been impossible, because of who she was and what she was made of, personally and publicly, for Liz to absent herself from life. She was too much of a trouper to slow down, and she was much too famous to be forgotten. The public wouldn't allow her to fade away, and she herself wouldn't have allowed such a thing to happen.

All the same, her days as the biggest box office attraction in Hollywood were now well behind her. Cinema in America had been radically remade in the late 1960s and early '70s, and the industry she was part of had limited need for the Elizabeth Taylors, Katharine Hepburns and Bette Davises. They might be offered a role in a costume drama or something camp, but no longer were studios clamoring after these actresses, who were now, ahem, of a certain age. What parts Taylor did play in this period were interesting for various reasons. In a 1980 adaptation of Agatha Christie's *The Mirror Crack'd* starring Angela Lansbury as Miss Marple, Taylor portrayed, quite convincingly and with good humor, a mature movie star. In the 1985 television movie *Malice in Wonderland,* she played gossip columnist Louella Parsons opposite Jane Alexander, who was cast as the Taylor family's old friend and Parsons' eternal rival, Hedda Hopper. Liz's last theatrical release was an adaptation of the animated TV classic *The Flintstones,* in which, in 1994, she incarnated Pearl Slaghoople. She would continue to do some TV—appearances on the soap operas *General Hospital* and *All My Children;* voice cameos on the seminal cartoon series *The Simpsons;* a small part in the irresistibly titled film *These Old Broads,* which starred pals Debbie Reynolds, Shirley MacLaine and Joan Collins—but, essentially, she sauntered into her retirement as a movie star.

As she did so, she strode forth in other areas. Her greatest later-in-life acting triumph was, somewhat remarkably, considering her always problematic health, on the stage. The headline of the *Time* magazine article in the issue of March 30, 1981, was "The Long Way to Broadway," and the secondary line was: "Her film career becalmed, Liz Taylor soars onstage." The first paragraph, too, is worth rereading, as it speaks so eloquently, today, as to where and who Liz was, right then:

"Ordinarily, conversation stops when a curtain goes up. But there is nothing ordinary about the current revival of *The Little Foxes,* and when the lights dim, audiences begin to buzz, like crickets waiting for dusk. 'Where is she? How does she look? Has she lost weight?' Only when she has been onstage for five or ten minutes, do the whispers stop and the answers become clear: in her first stage role, Elizabeth Taylor looks beautiful, gorgeous, radiant. In a word, sensational. 'I'm on a high,' she admits. 'I have a sense of accomplishment, a feeling of doing something useful in my life.' Raising her shoulders in a kind of happy shiver, she adds: 'And the applause is wonderful!'"

The playwright Lillian Hellman allowed this Broadway revival of her masterwork to happen only because of Taylor: "I've turned down a great many offers before this one, but Elizabeth is the right person at the right age at the right

HELMUT NEWTON

In 1985, Elizabeth and one of her latter-day pets, a parrot, pose in the pool at her home in Bel Air, California.
She goes without bathing cap, but never—never, ever— without rocks.

time." As the production progressed through its out-of-town tryouts before hitting the Great White Way, the producer Zev Bufman enthused, "She's the hottest draw I've ever seen! The tension is building. It's as if every night is an opening." At the Kennedy Center in Washington, President Reagan and Vice President George Bush were among those standing during the three curtain calls. Ron and Nancy, part of the old Hollywood gang in the Golden Age, went backstage to congratulate Liz.

"A lot of people thought that I wouldn't actually go through with this play," Taylor said just before the road show pulled into New York. "But once I make up my mind to do something, I do it. I go in the direction that I point myself toward. I don't let circumstances do it for me." She added: "I am a boisterous, raucous, down-to-earth, no-nonsense lady. I live life with a zest. It has never been dull for me, and I don't anticipate that it ever will be."

Broadway bowed down to her; the play's run was extended; she was nominated for a Tony award; the production was booked to move to London's West End, where, in the city of her birth, Taylor was again received as a conquering hero. The whole thing was so much about "Liz" that the agreement with her understudy on Broadway, Carol Teitel, stipulated that Teitel would stand in for Miss Taylor if—and only if—Miss Taylor became ill *during* a performance. When, in May of 1981, Taylor did take sick and was checked into Lenox Hill Hospital with a torn and inflamed rib cartilage that had been caused or exacerbated by a respiratory infection and a painful cough, performances were called off altogether. Apologies to the talented Carol Teitel, but she wasn't what this ticket was about.

Even if Taylor could no longer front a blockbuster movie, she remained the biggest star in the world. The year after her stage bow in *The Little Foxes,* she and Richard Burton had their fun onstage with *Private Lives,* but Liz had already proved her point: She was still here. So often in the subsequent years, that would be the message: She was still here.

And she made those subsequent years matter.

She not only reinvented herself as a diva of the stage, she solidified her standing as a cultural icon. A good way to do that—and to parlay the status into a profit stream—is to brand oneself. This Taylor did, lending her name and creative input to various lines of fragrances and cosmetics. In 1993, when she partnered with Avon on the Elizabeth Taylor Fashion Jewelry Collection, she said in her characteristically dry and disarming manner, "I think for me to go into the jewelry business is a bit of a natural." This first foray featured

baubles, bangles and beads that were based on some of her own possessions and things she'd worn in such films as *Cleopatra.* These costume items retailed for between $50 and $250, the kind of petty cash Elizabeth Taylor rarely dealt in. Later, in 2005, she would join forces with the model Kathy Ireland and Mirabelle Luxury Concepts for the House of Taylor Jewelry line. Ireland was said to be responsible for the affordable stuff, while the Elizabeth Collection was ultra high-end, with precious-stones jewelry routinely costing thousands, and some one-off creations going for more than a million. Ah, that's more like it! As if to stamp once and for all her credentials in this realm, the woman who wrote the book on jewelry wrote a book on jewelry.

Commercial companies claimed Taylor, and countries seemed to be fighting over her. She would eventually receive the French Legion of Honor and a Presidential Citizens Medal in the United States. Queen Elizabeth II dubbed her a Dame Commander of the Order of the British Empire during a Buckingham Palace ceremony in which the authentically English actress Julie Andrews was similarly elevated.

Why?

Is one given such accolades just for having been a movie star, even if a legendary one?

One is not.

Elizabeth's greatest and certainly most important role in her seniority was as a humanitarian. Specifically, she became the face of the fights against AIDS and the HIV virus. "I kept seeing all these news reports on this new disease and kept asking myself why no one was doing anything," she recalled. "And then I realized that I was just like them. I wasn't doing anything to help." The death of her dear friend Rock Hudson in 1985 was a catalyst to action for Liz. She teamed with Dr. Mathilde Krim to create the American Foundation for AIDS Research, for which she served as Founding National Chairman and not-to-be-denied front-woman. Her face appeared on posters, she testified before Congress. She wore out Larry King. She galvanized her friends in the Hollywood community (they honored her, too, at the Oscars, with the Jean Hersholt Humanitarian Award). Liz found her cause and her calling, and she stuck with it till the end of her days.

Of course, Liz being Liz, she continued to have a social life in this period. One of the best friends she ever made during her long life was Michael Jackson, and we will talk further of their relationship later in these pages. And then there was the Famous Parade of Husbands to attend to. If Richard Burton counts twice (as he should, so monumental

This Harry Benson portrait graced LIFE's February 1992 cover: "Liz Taylor Starting Over at 60." She was starting over with Larry Fortensky. Our editors bragged of the first joint interview about "their remarkable marriage."

was he in her life), then he is Husband Number Five and also Husband Number Six. That makes John Warner, whom she wed in 1976, Husband Number Seven. This handsome, accomplished man—World War II veteran, former Secretary of the Navy—began, during his six-year marriage to Taylor, a three-decade career as a moderate Republican U.S. senator from Virginia.

On October 6, 1991, at Michael Jackson's Neverland Ranch in California, Liz wed Husband Number Eight, Larry Fortensky, a construction worker 20 years her junior whom she had met in rehab. This union lasted five years—remarkable!—and Fortensky is best remembered today for

his '80s hair-band mullet and a poker hand named in his honor. (If you're not in the know: Four tens is a "Larry Fortensky.")

It's not only the number of husbands, it's the husbands themselves. Nicky Hilton . . . Michael Wilding . . . Mike Todd . . . Eddie Fisher . . . Richard Burton . . . John Warner . . . Larry Fortensky! Liz was really something.

Rumors in her later years were that she was not yet done with this marital business. There was this man or that one in her life. Maybe tomorrow, maybe next week.

Though she never did tie the knot again, she still had some living to do.

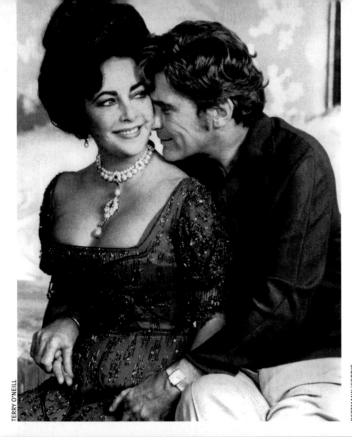

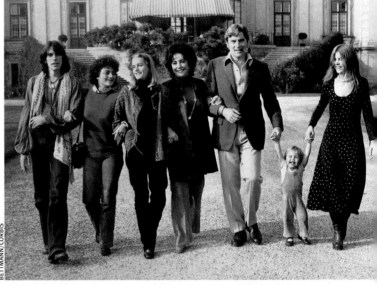

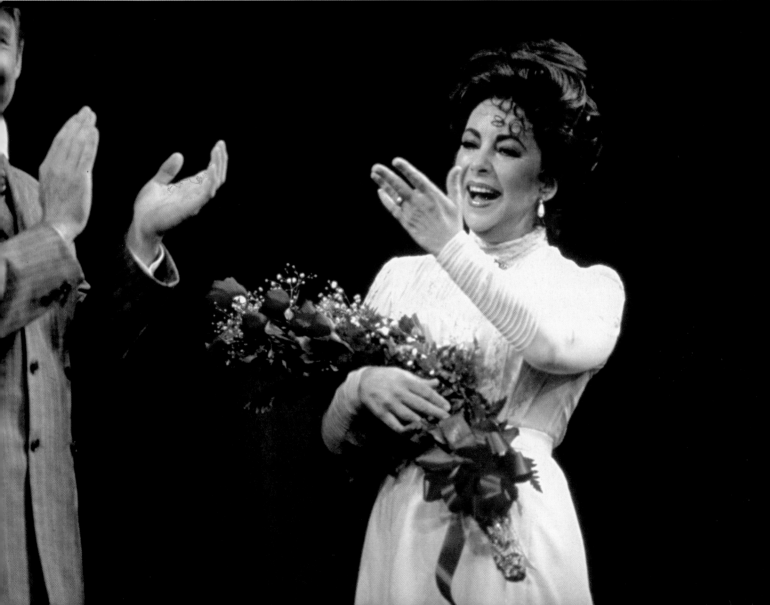

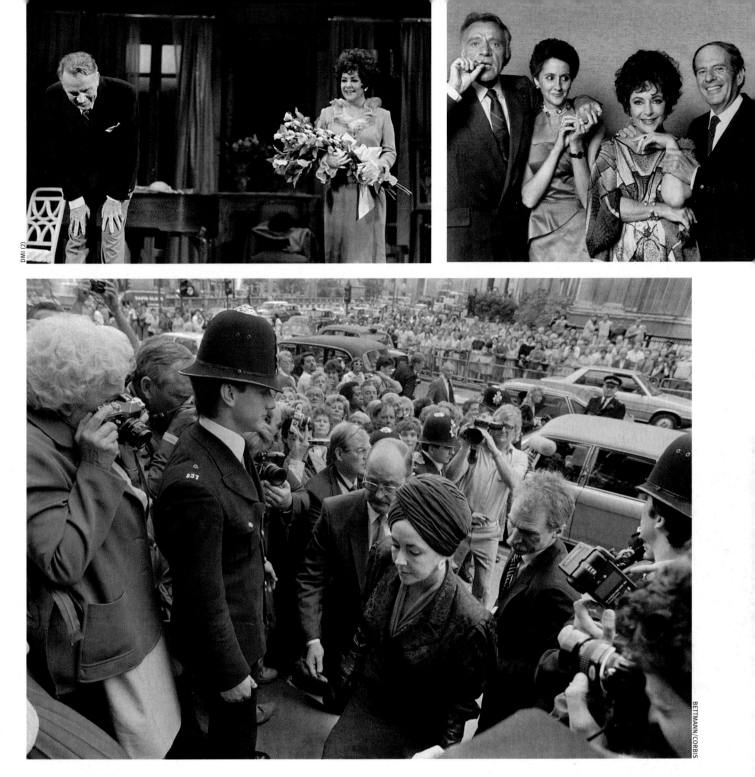

I n Liz Taylor's earlier pairings, the answer was usually obvious; in 1976, it was harder to make the call: Was he a lucky guy, or was she a lucky girl? Probably both. He was handsome, smart, accomplished and going places. She was beautiful—and all the rest. He was John Warner (opposite, top left, during his courtship), and when he and Liz announced their engagement on October 10, with their respective broods in attendance, the soon-to-be-formed family seemed an impossibly high-toned Brady Bunch (opposite, top right). Elizabeth and John would last six years: not bad at all. Meantime, Miss Taylor would go back to work in the brave new world of Broadway, which she conquered with seeming ease (opposite, bottom, taking a curtain call for The Little Foxes in 1981). Having proved her point talent-wise, she agreed to a 1983 media-sensation road show production of Noël Coward's Private Lives, with her ultra famous ex, Richard Burton (top left). In the adjacent photograph taken backstage are Burton and Sally Hay, and Taylor and Victor Luna—therein lies a tale. Burton's marriage to Hay, an English-born production assistant, on July 3, 1983, came smack in the middle of the seven-month tour of Private Lives, and reportedly displeased Liz. The following month she accepted a Cartier 16½-carat sapphire-and-diamond engagement ring from the Mexican lawyer Luna. One year later, Burton was dead. Above: Elizabeth arrives at St. Martin in the Fields church in London for Richard's memorial service. The day after this somber event, her publicists in the United States announced that the betrothal to Luna was no more.

She became, in the mid-1980s, a crusader. Here, clockwise from below, she comforts an elderly woman in a Washington, D.C., hospital in 1984; testifies in favor of AIDS-related research before the congressional subcommittee on Labor, Health, and Human Services and, years later, poses for a Kenneth Cole "We All Have AIDS" ad that hopes to raise awareness of the upcoming World AIDS Day. It is telling that, so large and durable was her fame and so associated with her cause had she become, she is in the center of the picture, while South African president and Nobel Peace Prize recipient Nelson Mandela, Harry Belafonte, Richard Gere, Tom Hanks, Natasha Richardson, Whoopi Goldberg, Greg Louganis, Sharon Stone, Ashley Judd,

Eric McCormack and Dr. David Baltimore are either stage left or right. (Dr. Baltimore, also a Nobel laureate, his in Physiology or Medicine, is just behind Taylor's right shoulder.) The fervor with which Taylor threw herself into the AIDS campaign was surprising to some of her friends; the pile of money she solicited or contributed to the cause grew miles high. When she sold a famous dress, the money went to fight AIDS. When she off-loaded a jewel that had begun to weigh her down, the money went to fight AIDS. When she ran out of wall space and auctioned a masterpiece, the money went to fight AIDS. Many celebrities dabble in good works. Discounting perhaps the accumulation of husbands, Elizabeth Taylor never dabbled in anything.

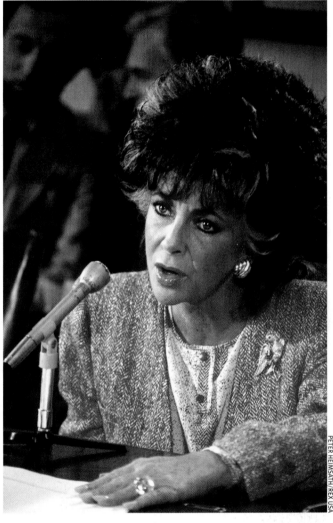

PETER HEIMSATH/REX USA

MARK SELIGER

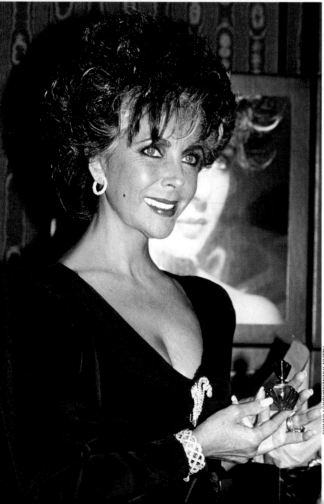

Certainly by the 1980s no one should have been the least bit surprised by anything Liz Taylor might do or say, or by any man she might arrive with. And yet! In the photograph above, she shares the hog of flamboyant multimillionaire Malcolm Forbes in 1987; at left, she introduces her perfume Passion that same year; and opposite, we have the Larry Fortensky chapter of her life, including the 1991 wedding in California's Santa Ynez Valley, with Liz wearing Valentino, plus two additional photographs by her friend Harry Benson, taken for LIFE's "Liz at 60" cover story in '92. For the record: The financier and magazine publisher Forbes was just a pal, and not— for once!—a lover, fiancé, husband or ex-husband. They enjoyed each other's company, they had fun together. After a shared ride on Forbes's Harley in a convoy with his Capitalist Tools motorcycle club, Liz declared with bountiful bonhomie, "I just wanted to go faster. We didn't go fast enough." That's our girl! As for the fragrances, there would also be Black Pearls, Gardenia, Forever Elizabeth, Diamonds and Emeralds, and, particularly, White Diamonds. And then there were the jewelry lines. There was the costume stuff sold on the shopping channels, but it wasn't until she was lending her name to one-offs that cost a million dollars per that we shouted, "That's our girl!" And, finally, Larry: Elizabeth once was marrying men 20 years her senior and now she was marrying one 20 years her junior, a guy she had met at the Betty Ford clinic. It seems curious on paper, but who among us has the experience that might be required to parse the passions of Elizabeth Taylor? She stuck with Larry for five years. Yes, after she filed for divorce in 1996, he had a few run-ins with the law: traffic and gun charges, an allegation of domestic abuse. But for a time —a few years—Elizabeth Taylor saw something in him. She was clearly looking for something when she saw whatever it was. Maybe Larry, at that particular point in time, truly had—and gave her—what she needed.

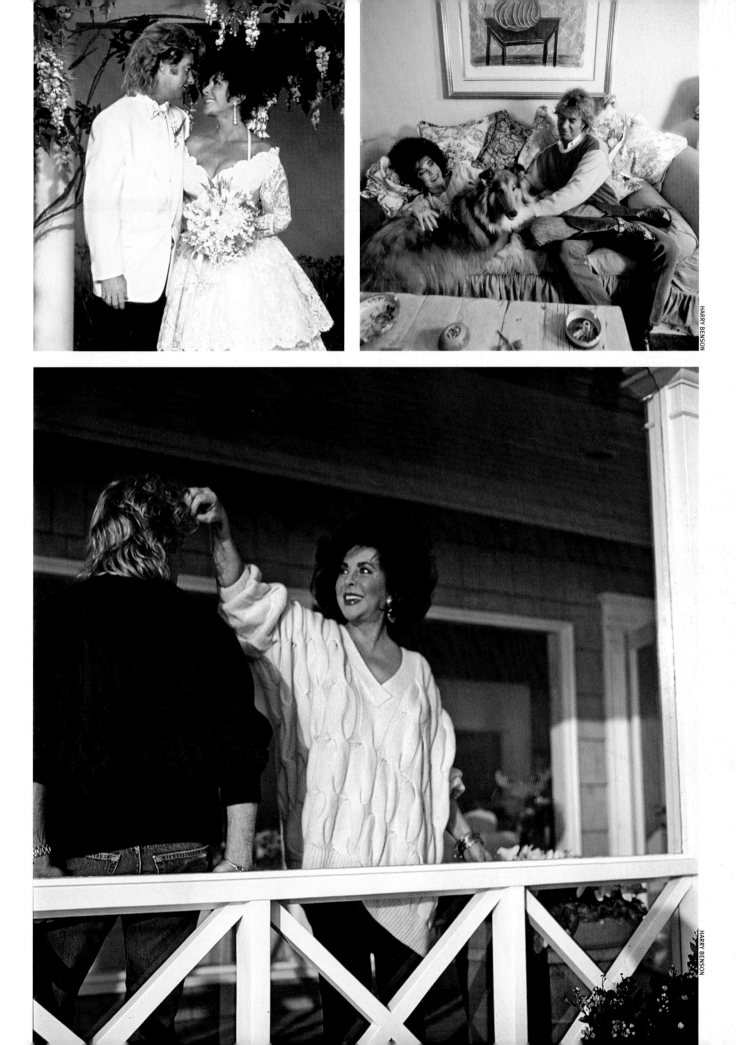

Legend
1997–2011

I N 1997, ELIZABETH TAYLOR, FORMER CHILD STAR, FOREVER QUEEN OF Hollywood, turned 65, long regarded in America as the classic age of retirement. To mark the occasion, the ABC television network asked if she would play along with a prime-time special: "Happy Birthday Elizabeth—a Celebration of Life." She agreed, once it had been worked out that a substantial contribution would be made to fund AIDS-fighting research. The day after the program aired in February, Liz, hoping to prolong life as much as celebrate it, went to the hospital to have a two-inch tumor removed from her brain. That was successful, as were, pretty much, the three hip operations. In 1998, she broke her ever troublesome back (she would break it on five occasions during her lifetime, including a break of her spine the following year, 1999, when she suffered a fall). There were, to be sure, other ailments. Lots of them. She explained late in life that she'd been born with scoliosis. Twice she fought off life-threatening bouts of pneumonia. In 2002, she underwent a radiation therapy treatment for skin cancer, and as long ago as 2004, she was diagnosed with congestive heart failure, a progressive condition. In October of 2009, she underwent heart surgery to replace a leaky valve. The following July, while responding to a rumored movie, the newly minted Twitter addict insisted she was in fine fettle—"Hold your horses, world. I've been hearing all kinds of rumors about someone being cast to play me in a film about Richard and myself. No one is going to play Elizabeth Taylor, but Elizabeth Taylor herself. Not at least until I'm dead, and at the moment I'm having too much fun being alive . . . and I plan on staying that way"—but in February of 2011, when her heart problems again landed her in L.A.'s Cedars-Sinai Medical Center, the rumor mill went into overdrive: *This time it's curtains!* It wasn't, not for another month, and Liz celebrated her 79th birthday by watching the Oscars from her hospital bed.

She entered life in a London hospital, the daughter of an actress and a successful art dealer from America. In 2010, Bonhams fine art auctioneers in London sold a signed Andy Warhol lithograph of her for £19,200. As we will soon learn, that was a pittance compared to what actual paintings of this icon commanded.

At no point was Liz Taylor unfamiliar with hospitals. Even discounting the stays in rehab, she can be regarded as a regular: She possessed an All Access pass to the OR, where according to legend she had, as we've mentioned earlier, more than 100 surgeries. If her very public bouts of ill health dated to that fall from a horse while filming *National Velvet* or to the even earlier infantile scoliosis, in her later years, decades of living the high life took a toll. Some said this was sad to see. But it was also inspiring to watch this brassy dame—make that, *Dame*—waving her hand regally to fans in loyal attendance as she was wheeled through the doors, a million bucks of gold and silver and serious stones weighing her down, surely exacerbating the osteoporosis. She was Cleopatra early on, and Cleopatra to the end.

She was the queen all through her later years, and also the matriarch. Her four children remained close—they were all at her bedside when she died on March 23—and had done well. Michael Wilding Jr. had enjoyed a long career as an actor (perhaps best known as Jackson Freemont on the soap *Guiding Light*). Christopher Wilding was a photographer and film editor. Liza Todd, who had been adopted by Richard Burton and then became, in marriage, Liza Todd-Tivey, was an equestrian sculptor in New York state. And then there was Maria, the German orphan whose adoption had begun when Liz was married to Eddie Fisher and had been completed during her marriage to Burton. Maria Burton Carson was a clothing designer, which certainly made her mother happy, and a philanthropist, which made her mother even happier, living in Idaho. It might seem surprising to some, but Elizabeth Taylor was a good and successful mother. And her children remained devoted to her.

As did her friends. She had a host of them, but none of the platonic relationships in her life would be as famous as the one with Michael Jackson. Others have noted, and it is perhaps worth mentioning, that Marlon Brando also was chummy with the much younger Jackson, and Jackson not only married Lisa Marie Presley but was close to Brooke Shields, Tatum O'Neal and Macaulay Culkin. The point of confluence for these seven well-known personalities, including Liz: All gained fame early on, or had fame thrust upon them. They understood one another. Make of that what you will, but Elizabeth and Michael became soul mates.

It was she who popularized Michael's famous King of Pop moniker in presenting him with Soul Train's Heritage Award in 1989. She became godmother to his children. She was his staunchest defender as he fought off the child-molestation charges that began in the 1990s and continued

for more than a decade. Their affection and loyalty were evident, genuine and fierce. Pop psychologists have worn themselves thin parsing the whys and wherefores of the Michael Jackson–Liz Taylor relationship, but at the end of the day it seems as simple as two showbiz equals meeting and growing to be intimate friends. Just as Liz treasured that last letter of Richard Burton's, she always kept close a photo Michael had signed, "To my true love, Elizabeth, I love you forever."

When Jackson died tragically young at age 50 in 2009, Taylor was at first "too devastated" to comment further. Her spokespeople said (without quoting) that she could not imagine life without him, and that life felt bottomless with his death. Immediately, Liz watchers feared that she would follow Michael to the grave, but even in grief, she was made of stern stuff. The day after Michael had passed, she tweeted: "My heart . . . my mind . . . are broken. I loved Michael with all my soul and I can't imagine life without him. We had so much in common and we had such loving fun together." She said, "I don't think anyone knew how much we loved each other. The purest, most giving love I've ever known." During Jackson's private funeral at the Los Angeles Forest Lawn cemetery, Taylor was one of the first to arrive and her wheelchair was placed at the end of a row of seats. She was obviously in deep mourning, but true to her resilient nature: A month later she was wheeling around the Universal Studios theme park as her godchildren, Paris and Prince Jackson, had a terrific time during one of the Halloween Horror Nights.

Life goes on.

Richard Burton, other former husbands, Rock Hudson, Roddy McDowall, Michael Jackson: Life goes on.

Life did go on, and Liz went on. The awards continued to pile up, and so did all the anniversaries—of her birth, her movies, of trivialities. "I had no idea that White Diamonds would become a classic when we began," Taylor told Kim Kardashian, of all people, for an interview in the March 2011 issue of *Harper's Bazaar*. "It is very special to me, and we certainly plan to celebrate this anniversary all year!" And what was this White Diamonds, whose 20th year was spurring such fireworks? As we've mentioned: perfume.

As she took her final bow, her fans wanted to hold on to her, wanted to celebrate everything about her. Her beauty, her bawdiness, her larger-than-life loves. We in the audience had admired, even revered other movie stars, but seldom had we reveled in the life of an icon as we did with Elizabeth Taylor. Somehow we lived more fully through her.

She was a piece of work, and a piece of art, on- and offscreen. With her passing, there are no more movie stars.

In May 2000, at London's Dorchester hotel (where once she cut a rug with Nureyev; please see page 73), Elizabeth is flanked by daughters Maria (left) and Liza and backed by sons Michael (left) and Christopher and their wives. The kids are celebrating Mom's investiture as a Dame Commander of the Order of the British Empire.

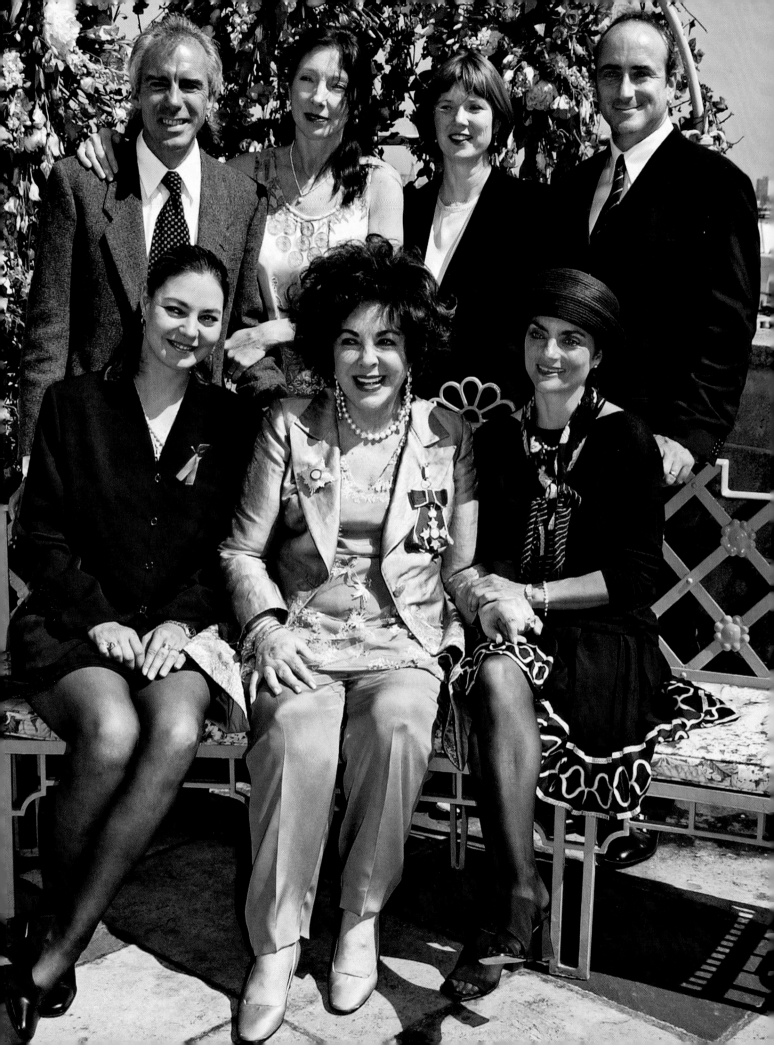

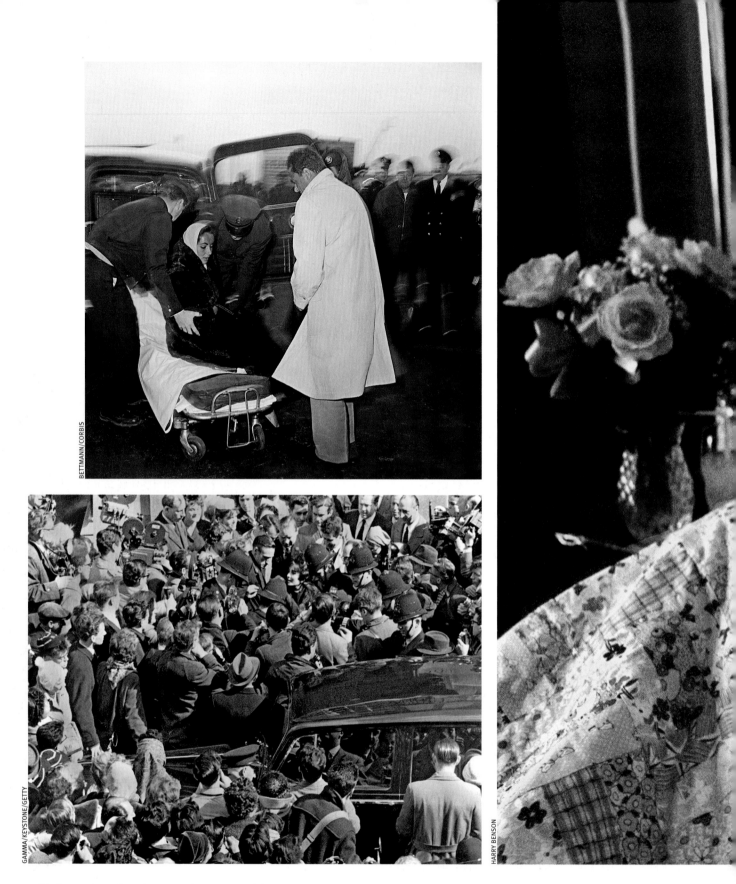

BETTMANN/CORBIS

GAMMA/KEYSTONE/GETTY

HARRY BENSON

S*he was legendary for many things. One of them, unfortunately: Liz was a legendary patient. Whether she ultimately spent more days on a movie set or more in a hospital would have to be toted up. Her back was, as we have said, a chronic problem, and late in life her heart was burdened—which was an irony for this ultimate queen of hearts, who had captured* so many and broken more than a few. On these two pages, we have the merest sampling of Liz-is-ailing pictures. The one at top left concerns, indeed, her back: She is, on February 10, 1957, being lowered onto a stretcher as her new husband, Mike Todd, looks on anxiously. They have just wed in Mexico, right after Elizabeth had undergone a spinal operation, and have arrived at New York

Just One More

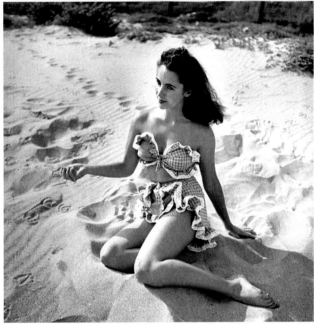

Photographed by Bob Landry

Photographed by Mark Kauffman

Photographed by Mark Kauffman

Photographed by George Silk

That's what we usually do here at LIFE on the last page,
we offer Just One More wonderful photo.
But with our friend Liz, this proved impossible. So here are
Just *Four* More portraits that first appeared in our pages.
Farewell, Elizabeth!

HARRY BENSON

LYNN GOLDSMITH

HO/REUTERS

So many of her friends had passed. The majority of her ex-husbands were gone. Roddy, Rock, Monty—all deceased, all long ago. But Liz soldiered on, and forged new bonds. The relationship that drew the most attention was with pop superstar Michael Jackson. When you looked at the résumés, it made perfect sense. They could talk intimately with each other about the whirl of child stardom, the pressures of fame and performance, the desire to do good and the yearning to be loved. They were two outsize personalities living outsize lives, as is exemplified in the picture at bottom, taken during Liz's 65th birthday TV special; in the one at left with Michael dressed to the nines to escort her to an event in 1986; and particularly in the photo at top, taken in Los Angeles in 1991, wherein Liz presents her friend with his Christmas gift, a real live elephant. This was quintessential Liz and had been for a long time: The biggest this or that (opposite, showing off the Taylor-Burton diamond one more time to her friend Larry King in 2001), the most this or that (at her death, she and King were precisely tied at eight marriages, seven spouses), the best this or that. Her estate was worth more than half a billion dollars when she passed away. She and Richard Burton had invested in real estate in the world's finest places, and she always remained Francis Taylor's daughter: Artwork he had helped her collect or appreciate—including paintings by Picasso, Pissaro, Monet, Utrillo, van Gogh, Renoir, Rembrandt, and on and on—had soared in value. But, interestingly, when she chose to sell a picture for charity, its worth didn't approach her own. In 2007, Andy Warhol's "Silver Liz," one of 13 paintings he made of her, brought $18.33 million at auction; and in November of 2010, his "Men in Her Life," a 1962 rendering of Elizabeth with Mike Todd and Eddie Fisher, commanded $63.4 million. These prices reflected Warhol's talent, certainly, but they also spoke to the allure of the subject. Elizabeth Taylor, in our culture, was literally and figuratively a work of art, and quite close to priceless. She will remain so forever.

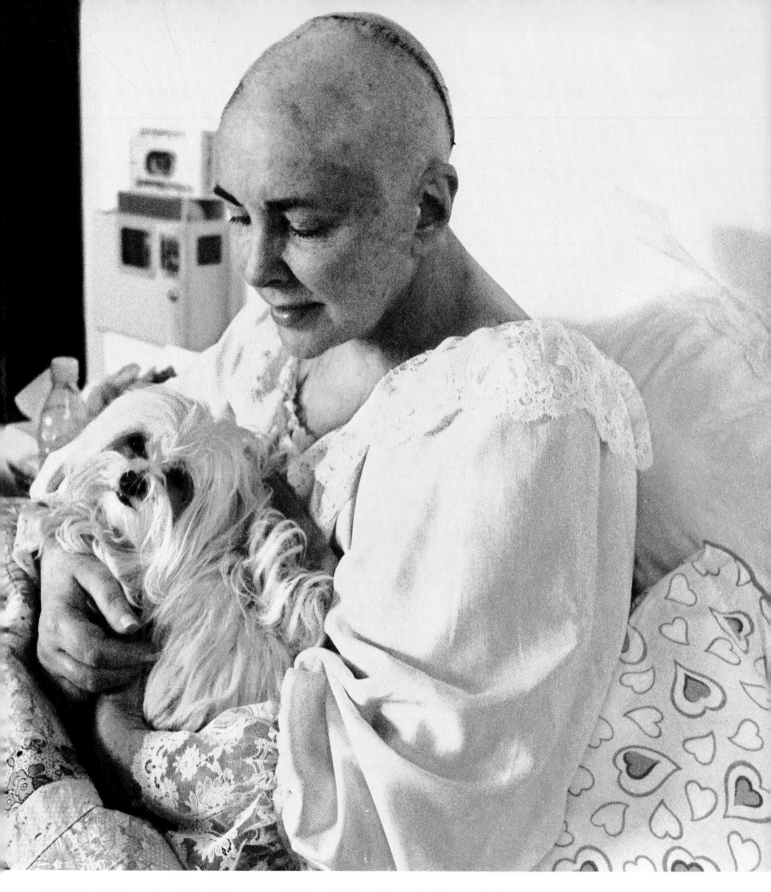

City's Idlewild Airport (now Kennedy International), from which a private ambulance will speed her to a romantic-as-is-possible honeymoon. Her back was a regular source of affliction, and so was pneumonia, which almost killed her on two separate occasions. Opposite, bottom, is a huge crowd celebrating her release from a London hospital in March 1961, after she has fought off a serious bacterial infection. The brain tumor in 1997 was, as said in our book's introduction, documented for LIFE—and for Liz and for her fans—by Harry Benson. The photograph above was taken bedside in the hospital. Said Liz at the time: "You have to put up your dukes and fight, even if you don't know what you're fighting against." She would keep on fighting for years well beyond this.